doodletopia
CARTOONS

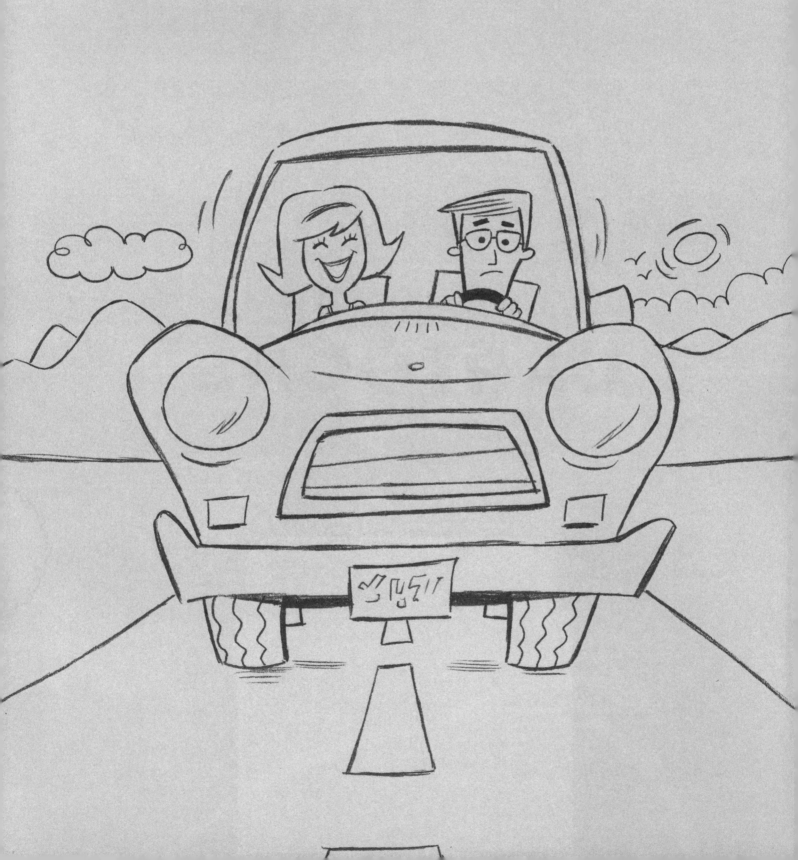

CHRISTOPHER HART

doodletopia
CARTOONS

DRAW, DESIGN, and COLOR
Your Own Super-Fun Cartoon Creations

WATSON-GUPTILL PUBLICATIONS
Berkeley

Published in the United States by Watson-Guptill Publications,
an imprint of the Crown Publishing Group, a division of Penguin
Random House LLC, New York.
www.crownpublishing.com
www.watsonguptill.com

WATSON-GUPTILL and the WG and Horse designs are registered
trademarks of Penguin Random House LLC

Library of Congress Cataloging-in-Publication Data

Hart, Christopher, 1957-
 Doodletopia : cartoons : draw, design, and color your own
super-fun cartoon creations / Christopher Hart. — First Edition.
 pages cm
1. Doodles—Technique. 2. Cartooning—Technique. I. Title.
 NC915.D6H37 2015
 741.5'1—dc23

 2015012259

Trade Paperback ISBN: 978-1-60774-691-1

Printed in the United States of America

Design by Betsy Stromberg

10 9 8 7 6 5 4 3 2 1

First Edition

For Francesca and Isabella.

Special thanks to my editor Patrick Barb, executive editor
Jenny Wapner, editorial director Julie Bennett,
publisher Aaron Wehner, and designer Betsy Stromberg.

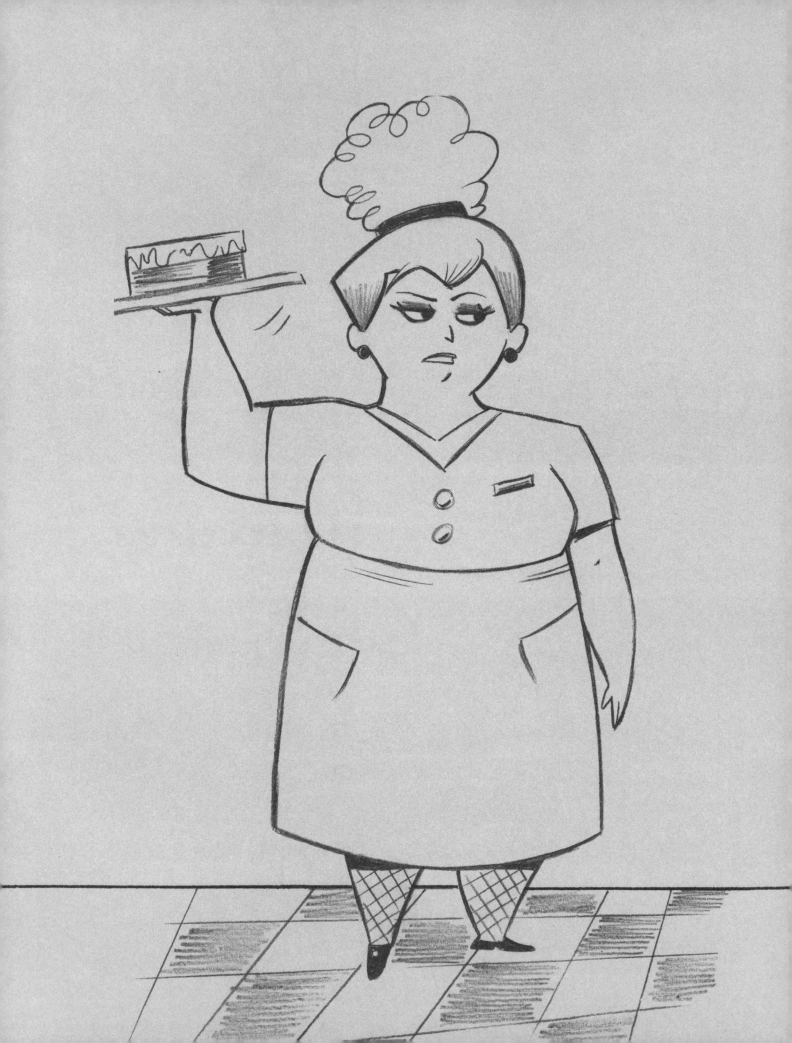

Contents

Introduction

If you're a doodler, you used to need to draw in the margins of notebooks, "to do" lists, and even on the back of receipts. But now you have an entire book to fill with your doodles. This book is about doodling cartoons. Everyone knows what a cartoon is. But what, pray tell, is a doodle exactly? A doodle is often thought of as a whimsical fragment of art. Doodles are fun to draw. They get your creative juices flowing. They keep you awake during team meetings.

What if you could enjoy the spontaneity of doodling, but end up with a real cartoon? This idea appealed to me. And it prompted me to think up this book. With each doodle, you'll draw a cartoon, which will entertain you, your friends, your family, and if they're exceptionally intelligent, your pets.

Aspiring artists often write to me and say that they find it hard to come up with ideas. This book will inspire you and help kick-start your imagination. I'll start each page with a drawing/doodling prompt, and you'll take it from there. Each chapter contains many projects for you to draw, design, and color.

Enough said. Get out your pencils. Let's get creative.

Follow the Guidelines

Before you begin to doodle, take a look at the two guidelines below—the center line and the eye line. You'll see these guidelines used throughout the book. They help artists find the correct placement for the features on the head. Using the guidelines will make the characters easier to draw and more consistent too.

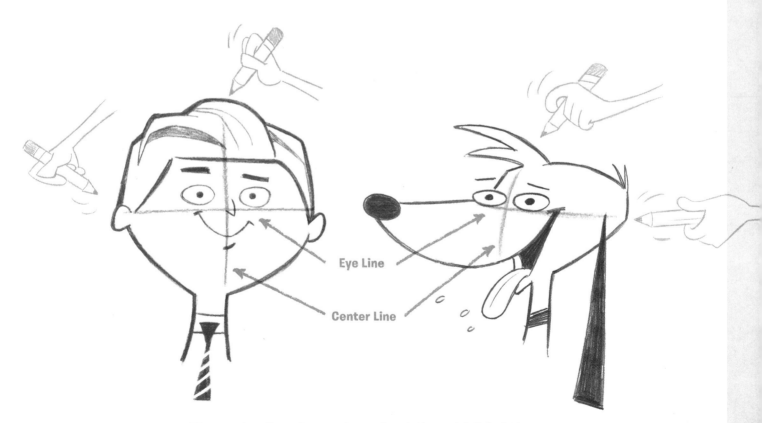

Eye Line

Center Line

The center line always goes down the middle of the face. However the eye line can move up or down to vary the placement of the eyes.

1

Warm Up

Let's get the artistic side of your brain warmed up and ready to doodle. I've designed some step-by-step cartoon drawing exercises to get you started. You'll see how the first few steps can create a solid foundation for a character, while the last steps add personality and detail.

When you finish this chapter, you'll be a lean, mean, doodle machine. Your confidence will soar. You will become ambitious. You will run for national office, be elected president, and enact all sorts of strange laws having to do with cartooning. But I'm getting ahead of myself. For now, these step-by-step exercises will suffice.

PLUMP PENGUIN

You'll never see a discernible waistline on a penguin. But that doesn't mean that they're sedentary. Far from it. In fact, they can do the fifty-yard dash in just under a week and a half. They have roly-poly bodies and small heads, with beaks of medium length. Notice that this penguin's chest is wider than its tummy—a unique feature of this adorable bird.

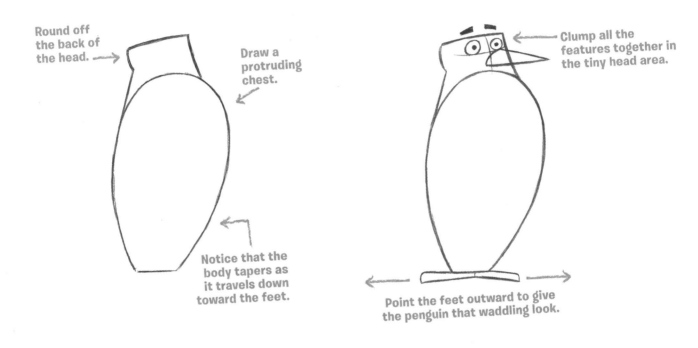

Round off the back of the head.

Draw a protruding chest.

Notice that the body tapers as it travels down toward the feet.

Clump all the features together in the tiny head area.

Point the feet outward to give the penguin that waddling look.

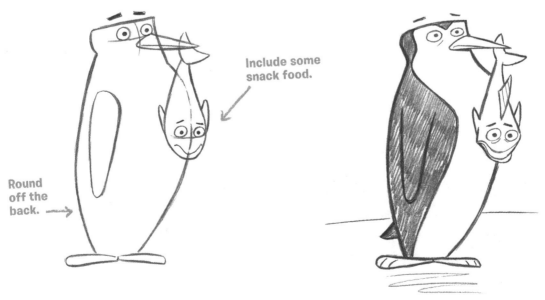

Include some snack food.

Round off the back.

The black-and-white markings make this character easy to identify.

Draw your own adorable penguin.

You can draw your penguin and all the cartoons in this book exactly the way you see them, or you can make your own changes to their designs. Maybe you just want to change an expression or a pose. If you want to go further and create your own penguin character, use the basic outline as a guide, and then alter it. Exaggerate the features (longer beak, bigger eyes, and so on) until your character takes on its own, unique look.

MASTER OF MANIPULATION

This character appears how I used to look when I really wanted something and my parents refused to buy it for me. I would pout until they caved. They were weak. This character is built with a huge head on top of a short and skinny body. He has intense eyes and a tiny, downturned mouth. Give his head an unwieldy mound of ruffled hair in the front.

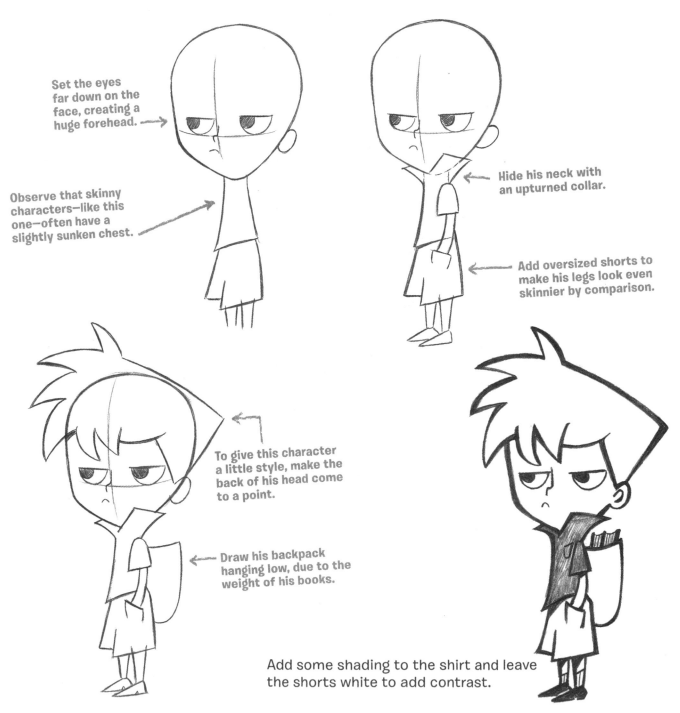

Set the eyes far down on the face, creating a huge forehead. →

Observe that skinny characters—like this one—often have a slightly sunken chest. →

Hide his neck with an upturned collar. ←

Add oversized shorts to make his legs look even skinnier by comparison. ←

To give this character a little style, make the back of his head come to a point. ←

Draw his backpack hanging low, due to the weight of his books. ←

Add some shading to the shirt and leave the shorts white to add contrast.

Draw your own funny kid.

A smug grin is part of the look of victory. Precisely according to plan, his parents have bought him a cell phone upgrade—anything to ward off more whining. Like the pouting expression, the smug smile features upper eyelids that rest on top of the pupils.

POPULAR TEEN

This character is an all-around nice guy. Teachers love him. Students admire him. He never gets into trouble. *Talk about a fictional character!* In the step-by-step example below, I've used a sketch guideline down the middle of his torso to help you visualize the direction of the pose.

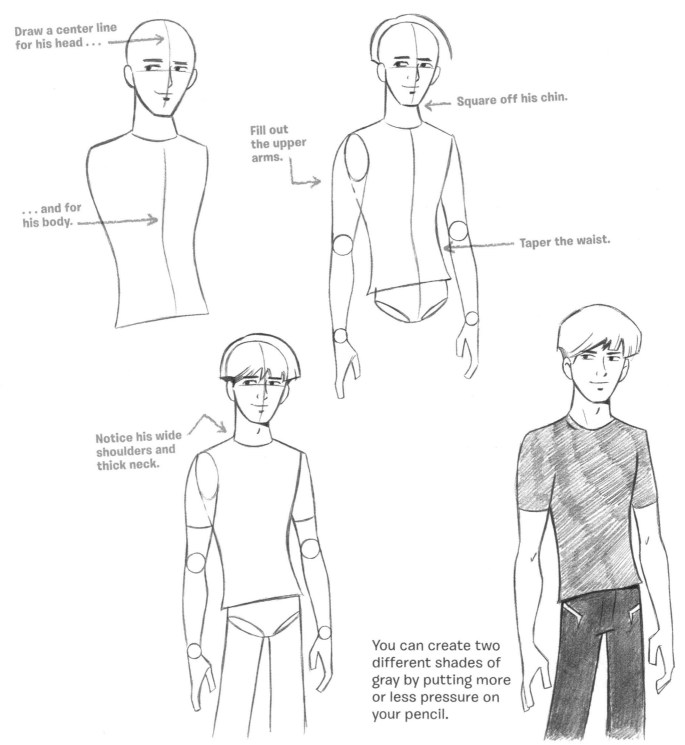

Draw a center line for his head . . .

. . . and for his body.

Fill out the upper arms.

Square off his chin.

Taper the waist.

Notice his wide shoulders and thick neck.

You can create two different shades of gray by putting more or less pressure on your pencil.

Draw your own cool guy.

This character is a natural poser. Look at his casual stance on the opposite page. It's taken him years of practice to get it right. This character is wide on top and skinny on the bottom. Make his arms extra-long for a gangly, teenage look.

FASHIONABLE LADY

It's important for cartoonists to keep up with current trends. If you draw a cartoon character wearing last year's style, your character may appear tired and dated. If you draw two characters wearing the same outfit, they may walk off the page and refuse to return. Get a hold of some fashion magazines for reference to avoid these issues.

In order to make the female body easier to draw, compartmentalize and simplify its various sections. As for her outfit: where you place the neckline and hemline are instrumental for creating a trendy look. Simplify trendy outfits to give them a streamlined appearance.

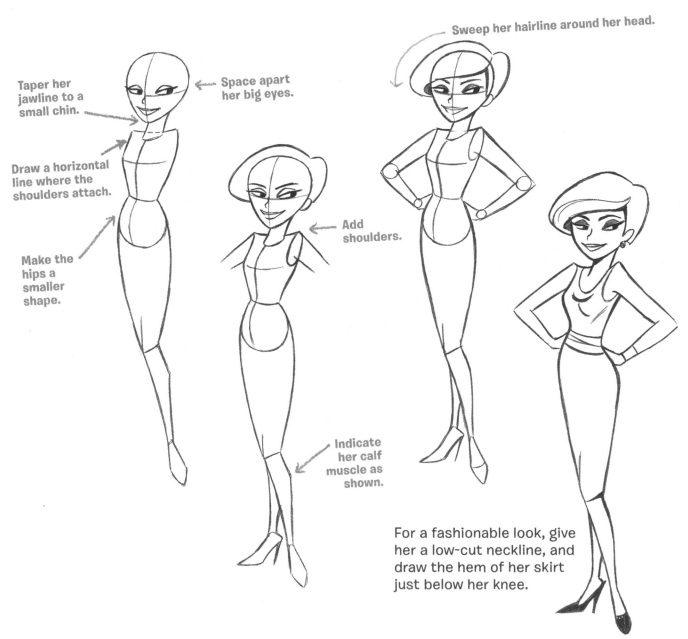

Taper her jawline to a small chin.

Space apart her big eyes.

Draw a horizontal line where the shoulders attach.

Make the hips a smaller shape.

Sweep her hairline around her head.

Add shoulders.

Indicate her calf muscle as shown.

For a fashionable look, give her a low-cut neckline, and draw the hem of her skirt just below her knee.

Draw your own glamorous lady.

Want to draw this fashionable woman in an easier pose?
Simply change her arm position so that the arms are behind
her back; however, keep the asymmetrical leg positions,
because this variety makes the pose more interesting.

MR. EGO

This character is a person who really looks up to himself. Everything about him says, *I wish I were me. And I bet you do too.* His pose is just too perfect. In other words, it's almost a cliché of a pose rather than a natural stance. He has a block-shaped head, a big chest, and short legs that taper down to small feet.

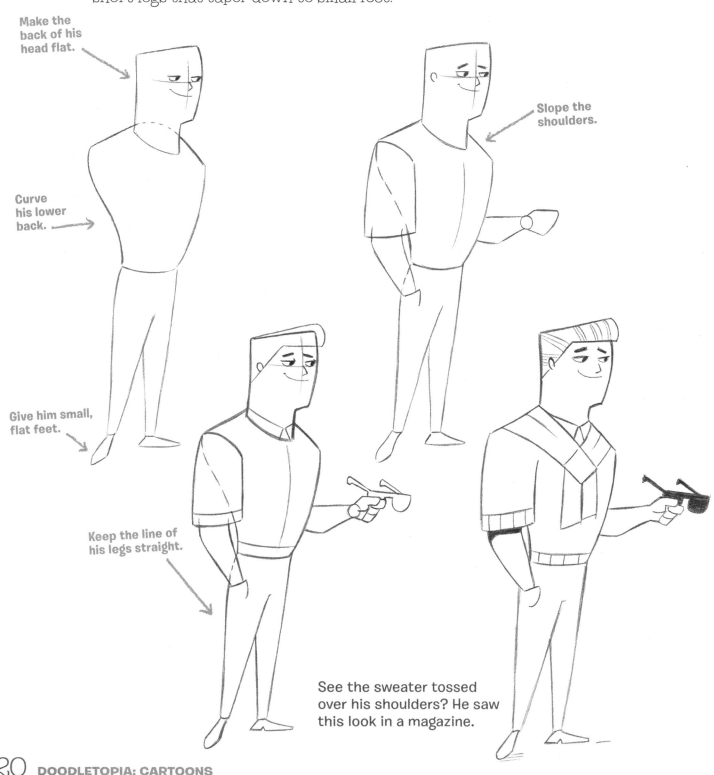

Make the back of his head flat.

Curve his lower back.

Give him small, flat feet.

Slope the shoulders.

Keep the line of his legs straight.

See the sweater tossed over his shoulders? He saw this look in a magazine.

Draw your own egomaniac.

Look at this character's laugh—he must have told a funny joke. The key to drawing this narcissist is found in his jaunty chin (and in his thick waistline). He may think he's hot stuff, but he's only a few cheeseburgers shy of *chubby*.

KOOKY CRANE

Large birds are awkward animals. They have no other purpose than to serve as material for cartoonists. Constructing this unlikely character starts with the addition of a tiny head and huge beak. That's followed by a winding neck, a compact body, and two sticks for legs. Its skull is almost a perfect circle, with an oversized beak hinged to it. A droopy beak makes this bird look even goofier.

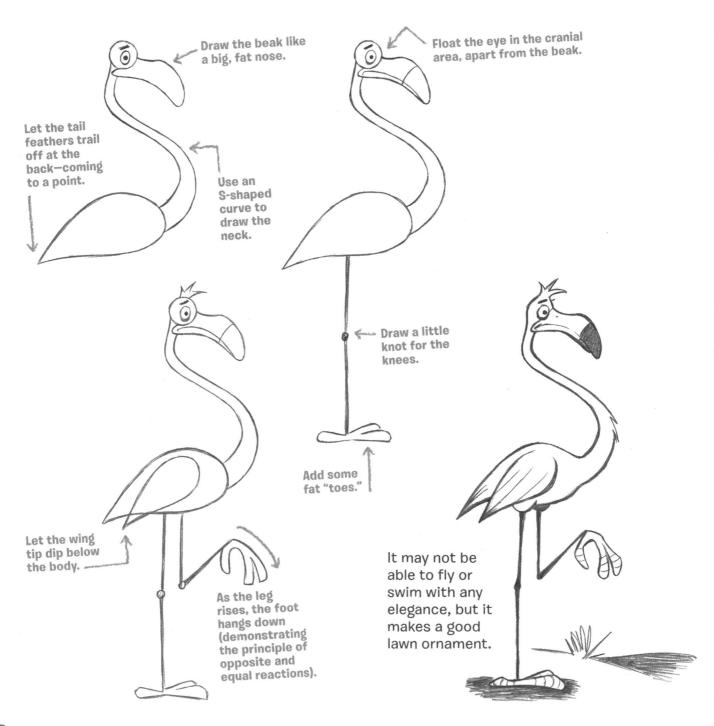

Draw the beak like a big, fat nose.

Float the eye in the cranial area, apart from the beak.

Let the tail feathers trail off at the back—coming to a point.

Use an S-shaped curve to draw the neck.

Draw a little knot for the knees.

Add some fat "toes."

Let the wing tip dip below the body.

As the leg rises, the foot hangs down (demonstrating the principle of opposite and equal reactions).

It may not be able to fly or swim with any elegance, but it makes a good lawn ornament.

Draw your own super-awkward bird.

Birds are built for flying. So if you want to make them look funny, draw them standing awkwardly on the ground. Another way to make birds look funny is to be totally random—for example, put birthday hats on them. In fact, *anyone* in a birthday hat looks funny. And so the lesson for today is: never let someone take a picture of you in a birthday hat.

FUNNY HORSE

This cartoon horse may be somewhat more challenging to draw than the previous examples; however, it's so goofy that you can hardly go wrong. I'm including extra steps to make it easier to follow along with me. If you follow each step in the progression, you'll be amazed how well it all comes together.

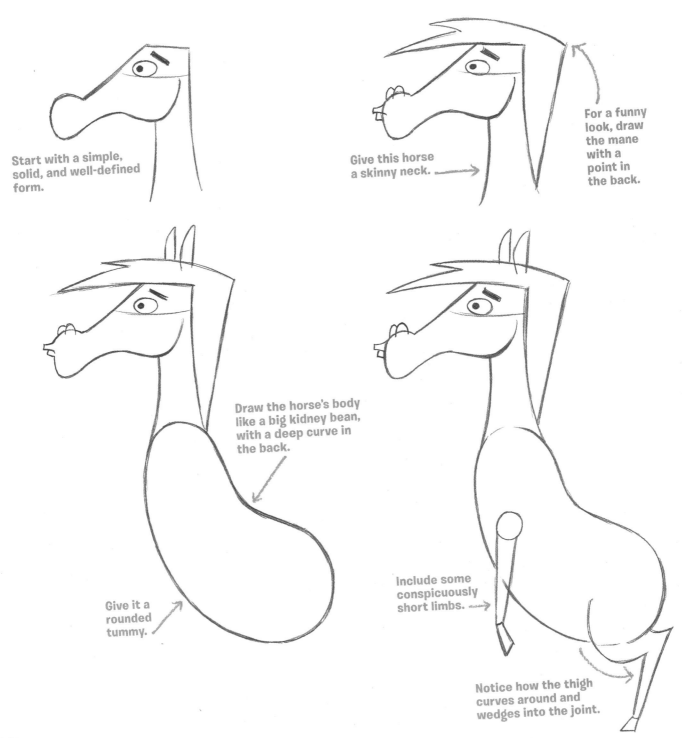

Start with a simple, solid, and well-defined form.

Give this horse a skinny neck.

For a funny look, draw the mane with a point in the back.

Draw the horse's body like a big kidney bean, with a deep curve in the back.

Give it a rounded tummy.

Include some conspicuously short limbs.

Notice how the thigh curves around and wedges into the joint.

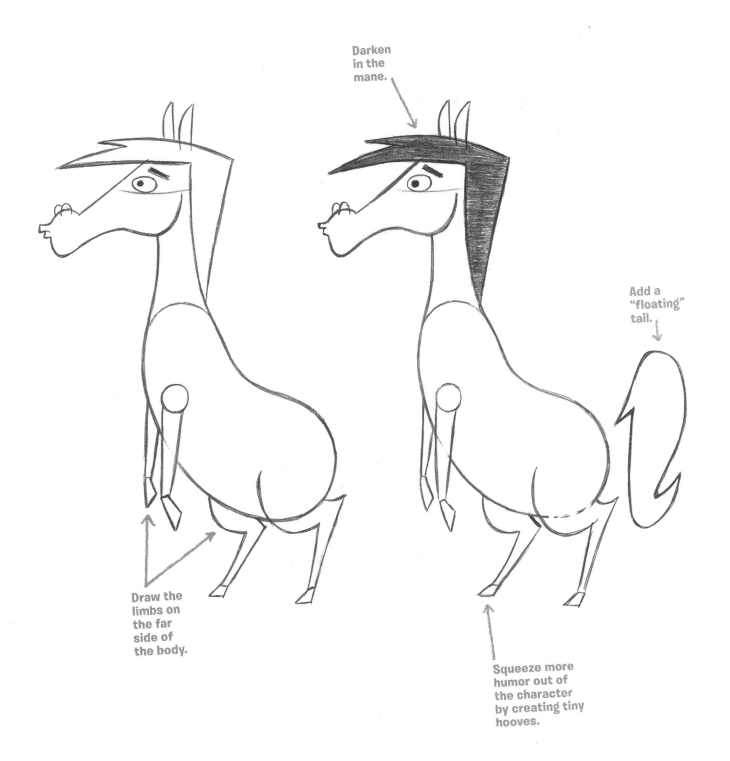

Darken in the mane.

Add a "floating" tail.

Draw the limbs on the far side of the body.

Squeeze more humor out of the character by creating tiny hooves.

DOODLE ON . . . ⟶

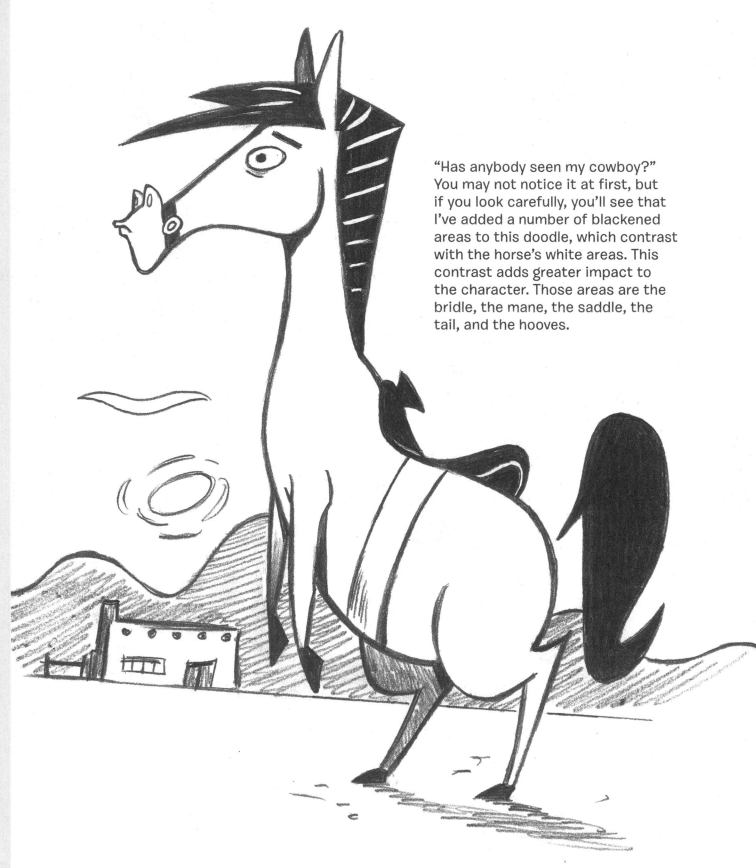

"Has anybody seen my cowboy?" You may not notice it at first, but if you look carefully, you'll see that I've added a number of blackened areas to this doodle, which contrast with the horse's white areas. This contrast adds greater impact to the character. Those areas are the bridle, the mane, the saddle, the tail, and the hooves.

Draw your own ridiculous horse.

When drawing your own horse, make the body funny by creating a big bottom. A big caboose on an animal is always funny. You can create a different look by doodling different types of manes, tails, or saddles. Or you could have no saddle at all.

2

Fill in the Silhouette

In this chapter, I'll show you a fun, new way to design characters and express your creativity. For each project in this chapter, I'll provide an example of a finished cartoon character, as well as its silhouette. Using the finished drawing as reference, you'll draw inside the silhouette to complete your own version of the character. I'll give you a jump start on each silhouette by drawing the guidelines (the center line and eye line) inside. Sometimes I'll also add the nose to give you an anchor around which to build the features.

WHAT'S SO FUNNY?

We all know a giggler—someone who laughs at all your jokes. (Then there's also the kind of guy who laughs at your haircut!) To create a more mischievous grin, simply draw his eyebrows tilting slightly downward, toward the bridge of his nose. Finish with a long, down-turned wisp of hair in front of his face.

HINTS

- Keep the eyes simple—don't try to do too much with them.

- Give the eyebrows some thickness.

- Add a funny spiral for the inside of his ear.

- Make sure the top of his head is pretty flat.

Draw this character laughing!

PERKY AND PRETTY

Here's a woman who's had one too many lattes. God help you if she sits next to you on the train during your morning commute. Perky characters are perky from the moment they wake up. They're perky when they work. They're perky when they do chores. They're even perky when they sleep. Perky people are cute. (And, also, super annoying.)

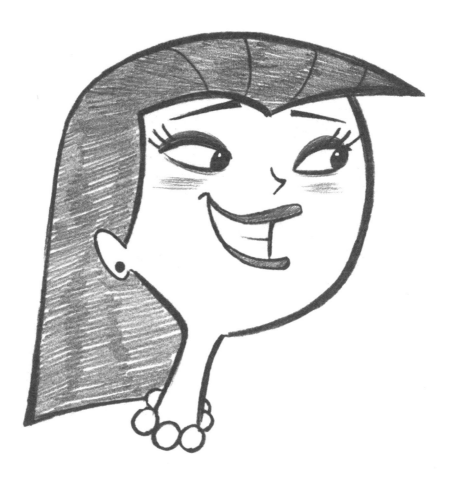

HINTS

- In addition to drawing long eyelashes, don't forget to shade her upper eyelids.

- Draw the eyebrows as sharp, thin lines.

- Make the lips extend past the teeth.

- Add some light streaks just under her eyes to create the look of blush.

Draw this energetic lady!

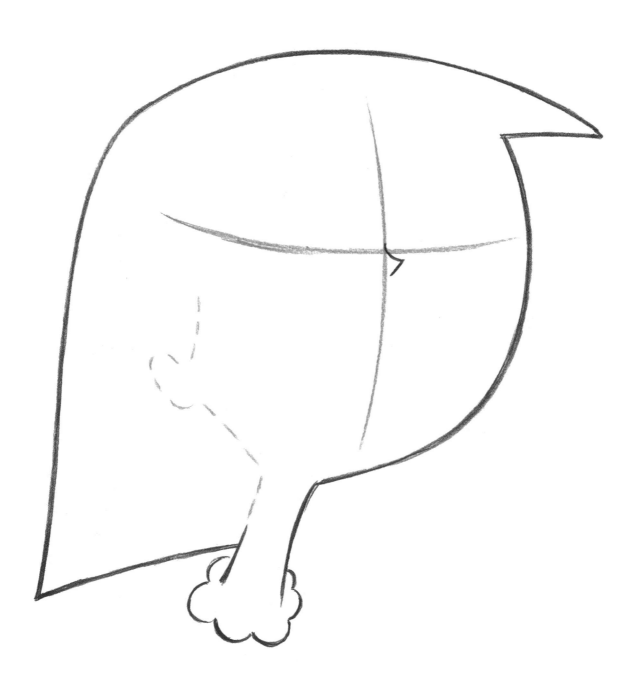

COLLEGE FRESHMAN

See this college freshman with a confident look on his face? He's just starting his first week of school. He's got an excited expression as he begins his new adventure. By midweek, he'll be lugging around fifty pounds of textbooks in his backpack and wondering if he'll ever smile again. Of course he will! Four years from now, right after he graduates!

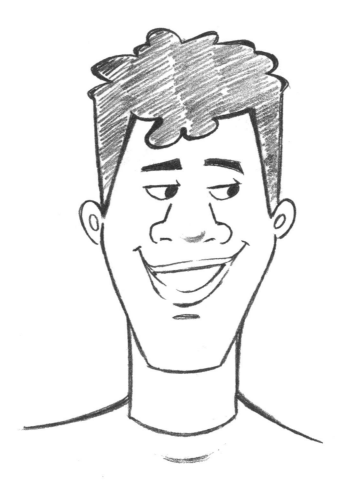

HINTS

- Draw the hair flat on the sides but bumpy at the top.

- Make sure the upper eyelids touch the pupils.

- Give the lips some thickness, but draw them so that they trail off into a thin line at both ends.

- Add a touch of shading to the tip of his nose.

Draw this funny undergrad.

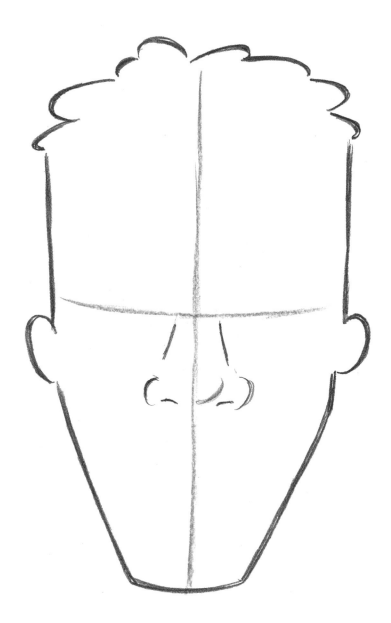

SCARED BEAR

What comes to mind when you think of a bear? A fierce and powerful animal? Toss those preconceptions aside, and introduce yourself to the typical cartoon bear. Don't let his meek appearance fool you. Under that nervous facade lies the heart of . . . a truly anxious individual. Think of him as a puppy in a bear suit.

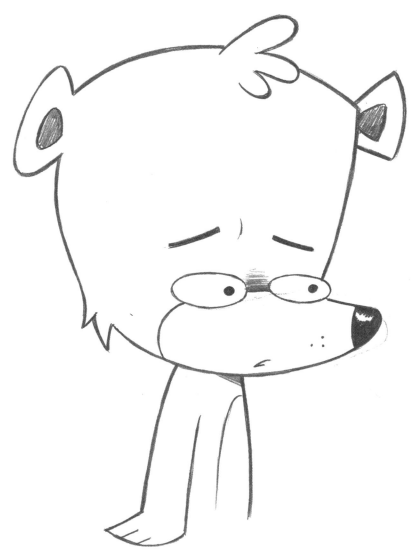

HINTS

- Draw the eyes as flattened ovals *overlapping* the muzzle area.

- Lift the eyebrows to create a fearful expression.

- To make him appear meek, draw his mouth tiny.

- Leave a little white on the nose to give the appearance of a shine.

Draw the rest of this timid teddy.

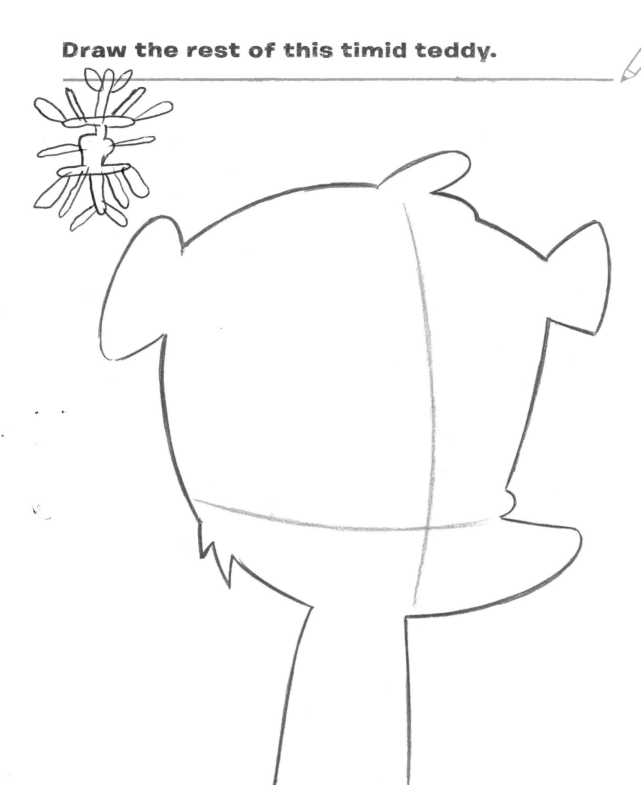

BIG BUDDY

This elephant is happy. Why is he happy? Because he's just spotted a human. Now the elephant will have a playmate! What game shall they play? How about the elephant's favorite: How Far Can I Toss This Person?

Poor elephant. He loses more playmates that way . . .

Cartoon elephants typically have small eyes, but everything else is oversized. Have fun drawing them. The goofier they look, the more appealing they are.

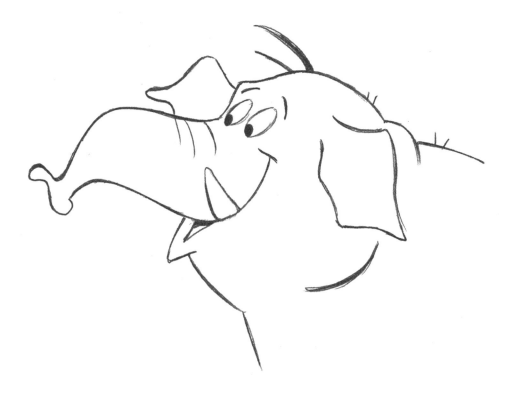

HINTS

- Draw the eyes on a tilted angle.
- Keep the tusk small and round, which makes the elephant appear cute.
- Draw the bottoms of the ears with a wiggly line.
- Draw the opened mouth in the shape of a narrow triangle.

Finish this ton of happiness.

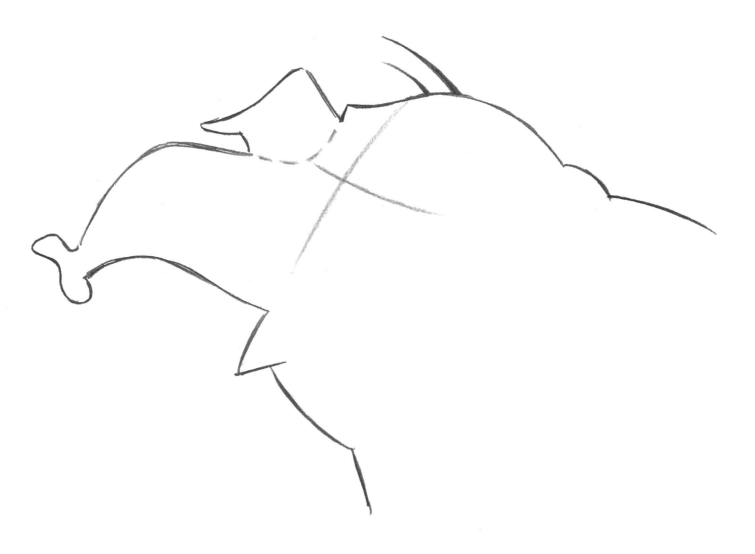

HOME SWEET CASTLE

They say that a person's home is his castle—except that a castle has a stable of horses, a giant dining hall for feasts, and special quarters for servants and cooks, and yours doesn't. Would it really make any difference to your life if you had untold riches and unlimited power? Oh. It would? Well in that case, let's start drawing up plans for your future home. Here's a cute starter castle. And there's even enough room for a moat and a jousting yard.

HINTS

- Center the turrets and flags on each tower.
- Overlap the towers, and draw them at varying heights.

- Keep the openings (the windows) small to make the castle look larger by contrast.

- Note the diagonal woodwork of the Tudor-style façade. You don't have to exactly match what I've drawn. You can make up your own design.

Fill in this humble abode.

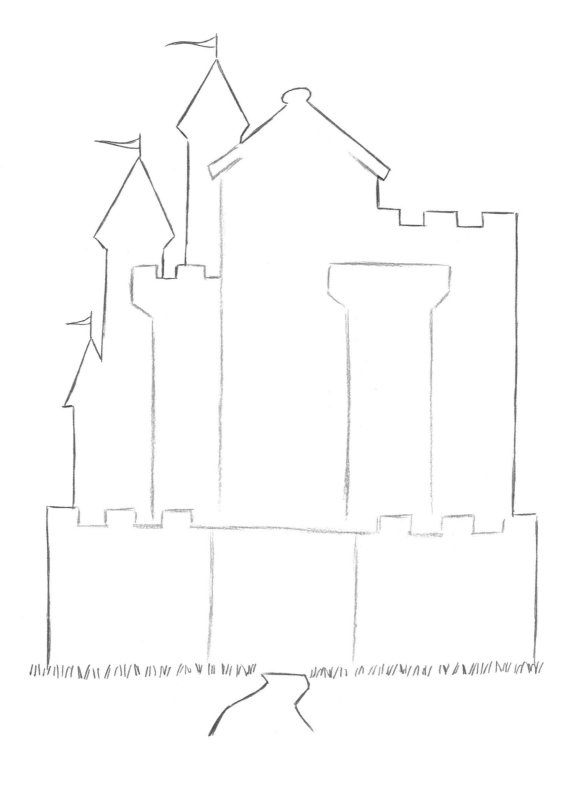

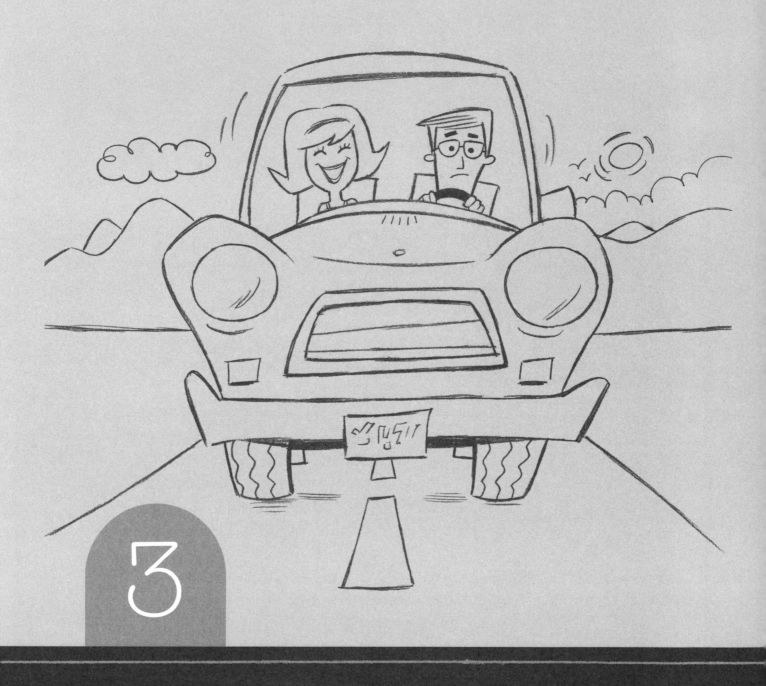

3

Draw the Other Half

I messed up and only drew half of each cartoon character in this chapter. I need someone to help me complete each drawing. I need a volunteer. Can I see a show of hands? Ah, you there! The person reading this book. I volunteer you for the job.

I'll start with a visual hint of what each character should ultimately look like. Then you'll draw the missing half of the larger drawing. The challenge is to match up both sides so that they look like one, continuous drawing.

Not only is this activity fun, but it also helps you master an important cartooning principle called *symmetry*. When you draw a face, the left eye has to be the same shape and size as the right eye. And both have to be drawn at the same level. This helps to make your drawings look balanced and correct.

COMPLETE THE PICTURE

You and I are going to team up on these drawings to finish them.
I'll draw the first half and you'll complete them.

The goal: Here's what
we want it to look like.

Complete the big image.

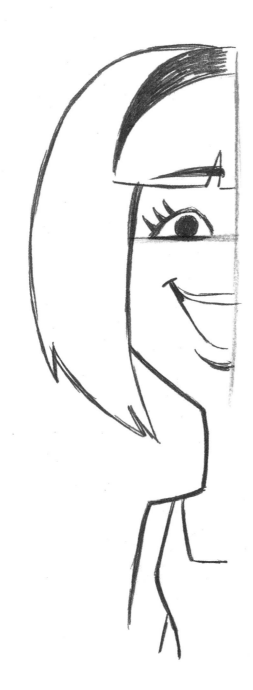

PRETTY WOMAN

When you draw appealing eyes and appealing lips, you're almost guaranteed to create an attractive character—unless you're drawing something like an iguana, in which case, it will still be attractive, but only to other iguanas. To draw pretty women, focus on the eyes. Short, thick eyelashes do the trick.

Make sure you line up everything so that each feature is on the same level—for example, both eyes, both eyebrows, and both ears.

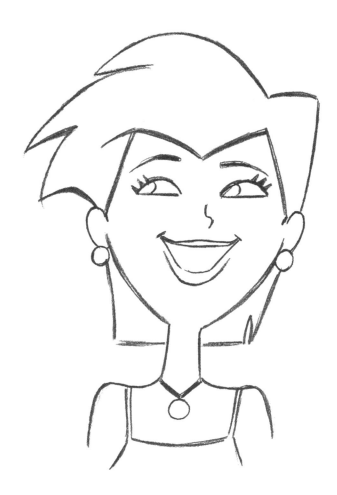

HINTS

- Make her upper eyelid an arching line and her lower eyelid a flat one.

- Notice that her upper lip is straight across, but the bottom lip has a deep curve.

- Because the nose is already pointed to the right for an asymmetrical effect, you don't need to include it on the other side.

- Make sure the arch of the eyebrows mirrors the arch of the upper eyelids.

Finish this cheerful character.

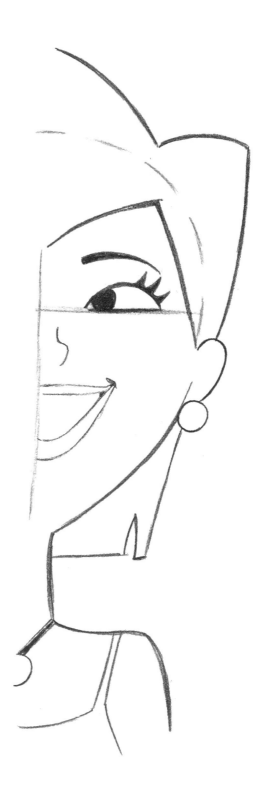

PANDA-MONIUM

Scientists don't know why, but there seems to be something about the combination of fat and fluff that makes pandas irresistible. Some people even want them as pets. But the upkeep is tough—very few local pet stores carry bamboo.

The key to the panda's excruciating cuteness lies in its shape. It's more than just round, it's also wide and thick. There is no visible waistline and no indentation at the elbows or the knees. Come to think of it, pandas are built like my Aunt Ethel. (That's probably the last time I get invited to a family reunion.)

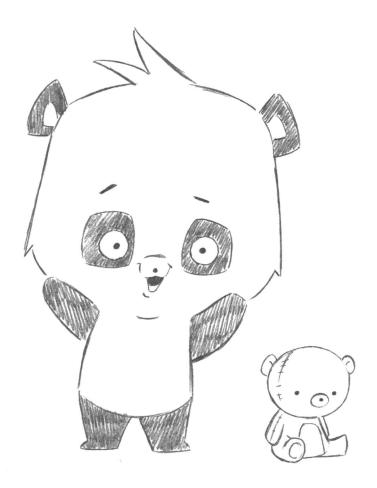

HINTS

- Draw the head larger than the body.
- Use uneven shapes for the eye patches.
- Make the panda's arms longer than its legs.
- Give the panda a pet.

Complete this panda's squeezable cuteness.

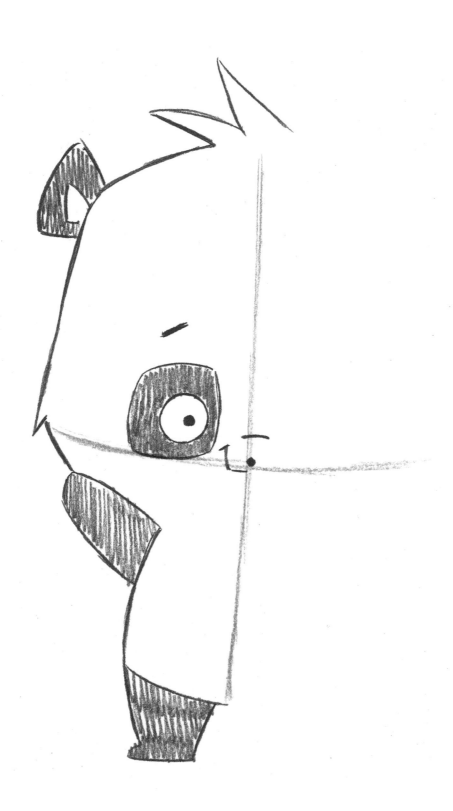

HI THERE!

When you see someone smile, it makes you feel good. When I draw a happy expression, I don't worry about the possibility of a giant asteroid slamming into the earth and wiping out all life as we know it on the planet. Although, now that I think about it, that is a little worrisome. Be that as it may, you should pair smiling expressions with bright eyes and raised eyebrows.

Check out this character's hand wave. Note his curved elbow. It's a funnier look than an elbow with an angular bend to it. Meanwhile, the character's other hand is in his pocket, indicating a casual pose. (Those somewhat wrinkly pants also convey a relaxed mood.)

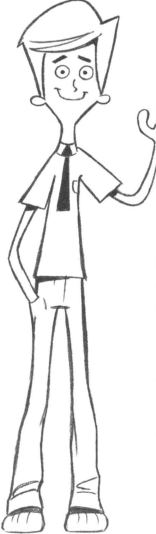

HINTS

- Draw bright eyes as circles, with the pupils floating in the center.

- Spread the fingers apart for a "hello" gesture.

- Spread his legs shoulder width apart.

- A small chest with slightly wider hips gives a humorous look to thin characters.

- It's funnier if you create soft bends for the elbows, rather than angular ones.

Draw the rest of this cartoon "Hello!"

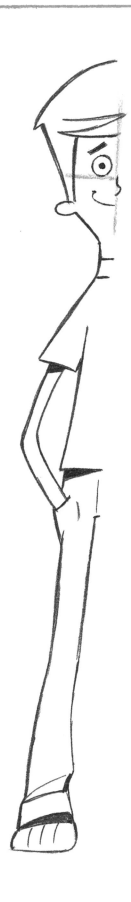

ANGRY WAITRESS

Be careful. This waitress is carrying a cake, and she isn't afraid to use it. What's she so upset about? A customer commented that his meal tasted funny. How *dare* anyone make a negative comment about her canned pork?

Do you like her hair? No doubt it was cut by a hairstylist who forgot to wear contacts that day. This waitress reminds me of a grade-school cafeteria worker. Ah, memories . . .

HINTS

- Create her angry look with a sidelong glance.

- Don't forget to shade her eyelids.

- Give her wide shoulders.

- In order to simplify the outfit, her apron doubles as a dress.

Finish this waitress with a bad attitude.

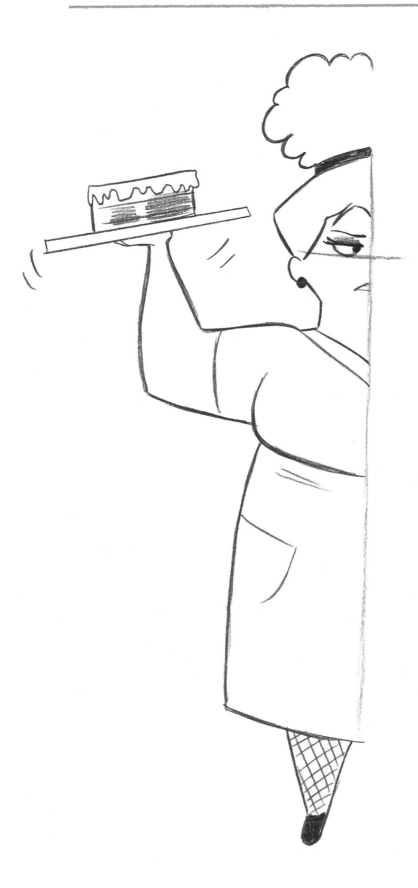

DON'T WORRY, HONEY, I KNOW EXACTLY WHERE WE ARE

This driver may have started out on a day trip to the Hamptons, but now he's closing in on Guam.

Cartoonists try to draw inanimate objects as humorously as they draw people. This car is a good example. Realistic cars are low to the ground. But the typical cartoon car has the same basic proportions as a shopping cart. The windshield is tall, which provides the room necessary to clearly show the driver and the passenger inside the vehicle.

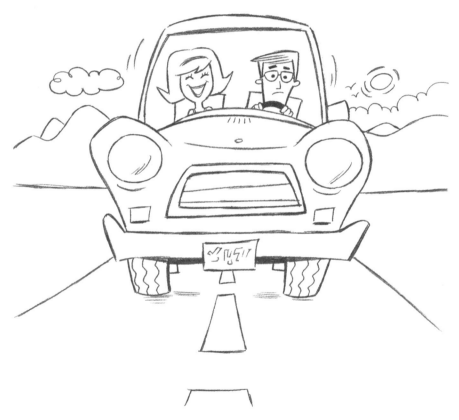

HINTS

- Show the top of the seat behind each character.

- Giant headlights give the car personality.

- Place the dashboard line just above the hood of the car, and place the steering wheel above that.

- The fender looks like it's about to fall off.

- Squiggly lines represent tire treads.

- Include the driver's-side mirror for an added touch.

Complete the sedan-to-nowhere.

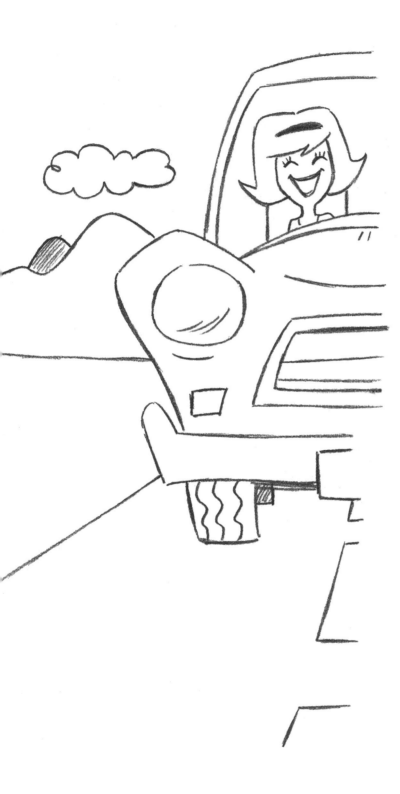

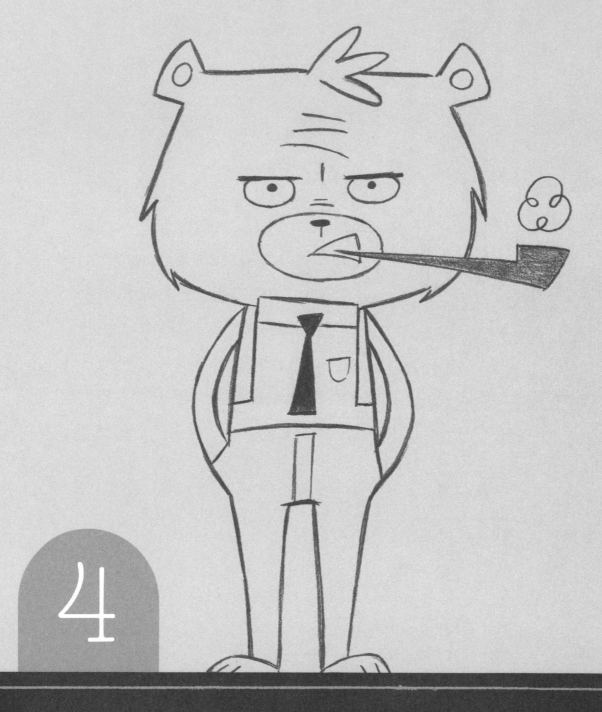

4

Select Different Expressions

Cartoonists love to draw expressions. A funny expression lights up a character and makes it appear engaging. The eyes and mouth have to work together to make an expression clean and easy to read. Here's where the sketch guidelines come in handy. When you draw expressions, you change the shape of the features. If you're not careful, it can affect the overall structure of the face. Sketch lines help to keep things from going out of whack.

Enjoy doodling the expressions in this chapter. May the funny be with you.

DAD OF MANY FACES

The cartoon dad is not so much an authority figure as he is a *non-authority* figure. His kids don't respect him. His wife doesn't respect him. At least the dog takes him out for a walk on the weekends. Notice that his features are all clustered around his oversized glasses? That sort of bunched-up appearance creates a humorous character design.

Expression Options

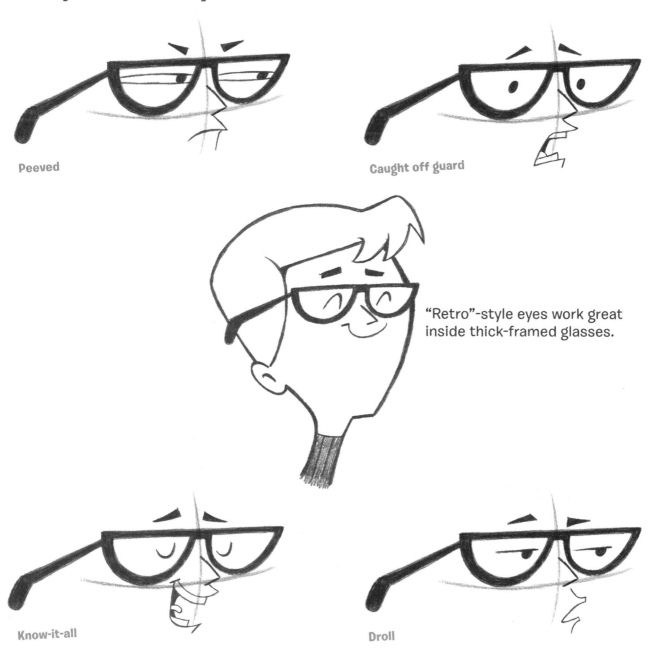

Peeved

Caught off guard

"Retro"-style eyes work great inside thick-framed glasses.

Know-it-all

Droll

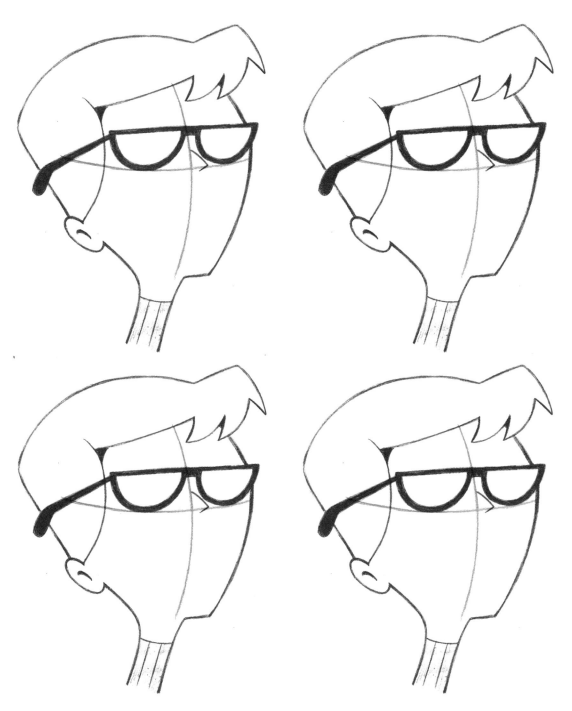

The cartoon dad is a versatile and popular cartoon character. You can create endless variations. There are younger dads, middle-aged dads, office-worker dads, superhero dads, and dads who are annoying because they try to act cool. But the thing all these dads have in common is that they have a closet full of ugly neckties!

TEACHER'S PET

This grade-school girl character is loved by her teachers. She always
has her hand up, ready to answer questions. But when teacher is
not around, she mercilessly teases the girls and torments the boys.
The hallmarks of this character are her cute, upturned nose and
prominent eyelashes. Because she's such a chameleon, she has a
huge range of exaggerated eye expressions. The bow in her hair gives
her a sweetly diabolical look.

Expression Options

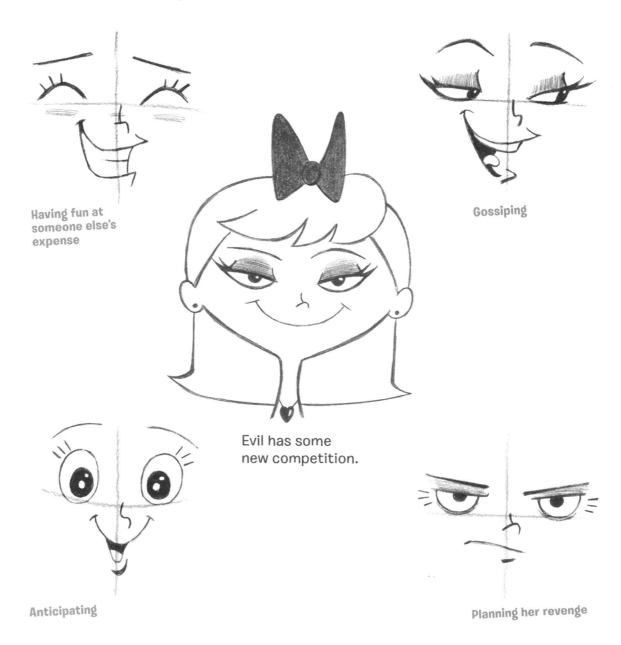

Having fun at
someone else's
expense

Gossiping

Evil has some
new competition.

Anticipating

Planning her revenge

For typical cartoon characters, you would give the eyes and the mouth relatively equal weight for all expressions; for this character, however, focus on the eyes. This is because her evil glint is so important. Note that the pupils themselves dilate or contract depending on her expression.

SUPER PRETTY LADY

The eyes do the communicating for pretty female characters. Draw the eyes dark (i.e., with a strong, dark line) in order to direct attention to them. Make the lips thick—the thicker the better. To add a bit of style, draw a lighter line where the two lips meet in the middle. Pretty characters often purse their lips together, for a coy expression. Only a pretty character can get away with looking coy. You rarely see a cartoon of a construction worker with a coy expression. And if you did, it would be unsettling.

Expression Options

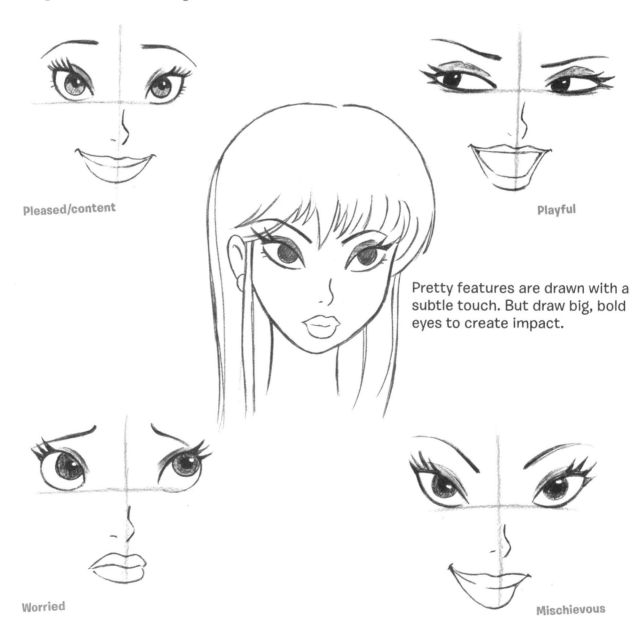

Pleased/content

Playful

Pretty features are drawn with a subtle touch. But draw big, bold eyes to create impact.

Worried

Mischievous

Your Turn

The eyebrows are thin lines, but they still have a little bit of width. They taper at the ends. If the eyebrows didn't have that tapering effect, they wouldn't look as feminine. Some artists add a little oval on the lower lip to indicate a shine. I think this is overkill. If you draw an oval on the lower lip, I will have to write you up a ticket.

HORSE TOON

Animal lovers often say that there is no nobler creature than the horse. So, it's up to us cartoonists to wreck that concept! Horses are great fodder for cartoons because big expressions look so unlikely for an animal with such a small mouth area. Also, its eyes can be rearranged to go on the front, rather than sides, of the head.

Expression Options

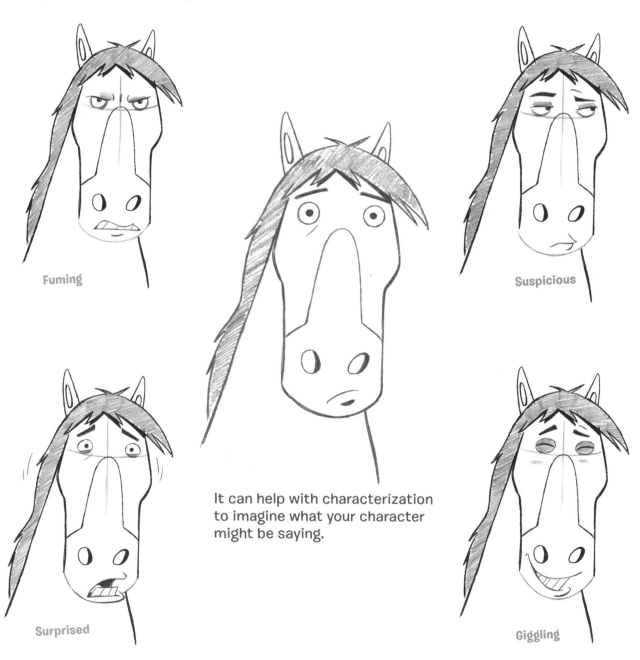

Fuming

Suspicious

Surprised

It can help with characterization to imagine what your character might be saying.

Giggling

Your Turn

Start with any expression you like, or create one from your imagination. When drawing the horse's mouth for any expression, keep it compartmentalized within the muzzle. The mouth shouldn't get too close to the nostrils, or the expressions will look cramped.

WATCHDOG

A cartoon watchdog will watch any burglar that enters his home, and then watch the burglar leave. Why should the dog care? It's not his stuff that's getting stolen. This dog's eyes rest on top of the bridge of his nose (which has a few wrinkles in it). I like to give watchdog characters strong eyebrows to make them look intimidating. The nose can be as simple as an oval, or you can indicate nostrils. Notice the short, vertical line that runs from the bottom of the nose to the mouth. That line gives the pooch something called a "split lip," which is evident on real dogs and is usually exaggerated for cartoons.

Expression Options

Sympathetic

Anticipation

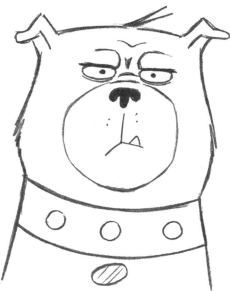

This hyper-vigilant guard dog has a funny intensity, no matter his expression.

Y-y-yuck!

Grrrr!

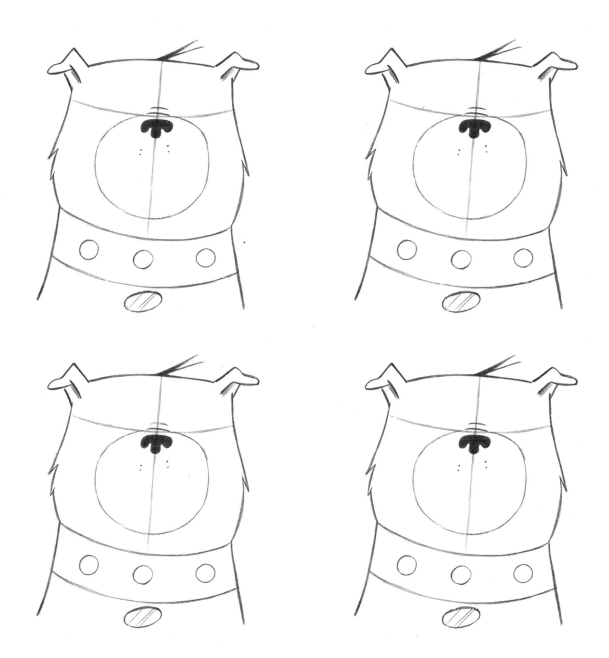

Dogs' faces have a few extra elements that you can play with to create funny expressions. These include sharp teeth and floppy tongues. You can even give this dog square, little human teeth, for an added joke. That ring you see drawn around the dog's mouth is a marking that cartoonists typically use to bring more focus to the center of the character's face.

PAPA BEAR

Cartoon bears are often depicted as part of a family. I like to caricature the adult male bear as a retro 1950s-style dad. Can you guess what makes him look human? Nope, it's not the pipe. It's the forehead wrinkles! Dad characters love to give advice, but no one listens. This sort of runs across all species.

Expression Options

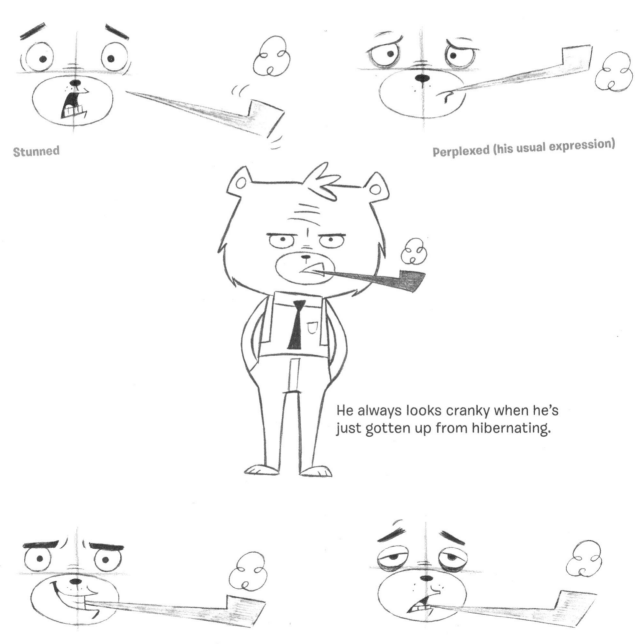

Stunned

Perplexed (his usual expression)

He always looks cranky when he's just gotten up from hibernating.

Confident (for absolutely no reason)

World-weary

This bear is drawn in the tradition of all the popular cartoon "dads," with the exception of his ears and fur. He's dressed conservatively, which makes him funny—in a weird sort of way. I like to give dad characters thick eyebrows— or even a unibrow. A mustache or glasses can also make for funny additions. Try it, and see what you can come up with. Remember: the pipe can tilt up or down as his expression changes.

5

Choose and Design the Animals

This is one of my favorite parts of this book. You're going to see how you can create two completely different animals from one shape. Not only that, but both characters' expressions will remain the same! Can't be done, you say? The ravings of a madman? They said the same thing when I announced my plans to create a submarine out of cardboard. And with a little tweaking, it would have worked—but they cut off my funding. Anyway, in this chapter, you're going to create some amazing transformations.

A PORCUPINE OR A BEAR?

What do a porcupine and a bear have in common? Almost nothing!
And yet, you can draw both of them from the same basic construction.

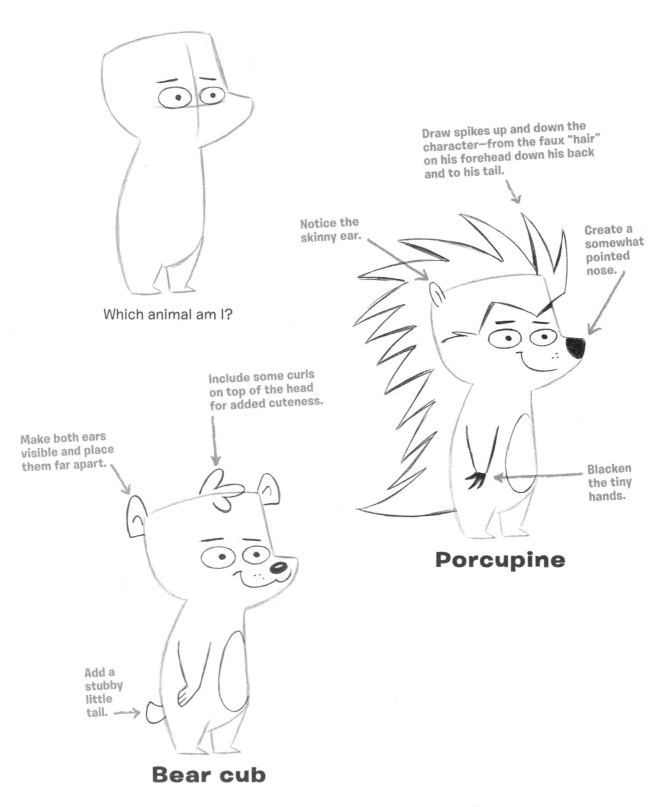

Which animal am I?

Draw spikes up and down the character—from the faux "hair" on his forehead down his back and to his tail.

Notice the skinny ear.

Create a somewhat pointed nose.

Blacken the tiny hands.

Porcupine

Include some curls on top of the head for added cuteness.

Make both ears visible and place them far apart.

Add a stubby little tail.

Bear cub

Draw a porcupine (ouch!) and a bear cub!

A PIG OR AN ELEPHANT?

What do a pig and an elephant have in common? Both are feared at the buffet table. In addition, both have super-round heads, with eyes placed in the middle (not high or low) on the face. Tiny eyes are funnier than big eyes, and they both share that quality. Both have snouts, but elephants have the deluxe version. And finally, they both have a few ridges (indicated by repeated lines) just above their noses.

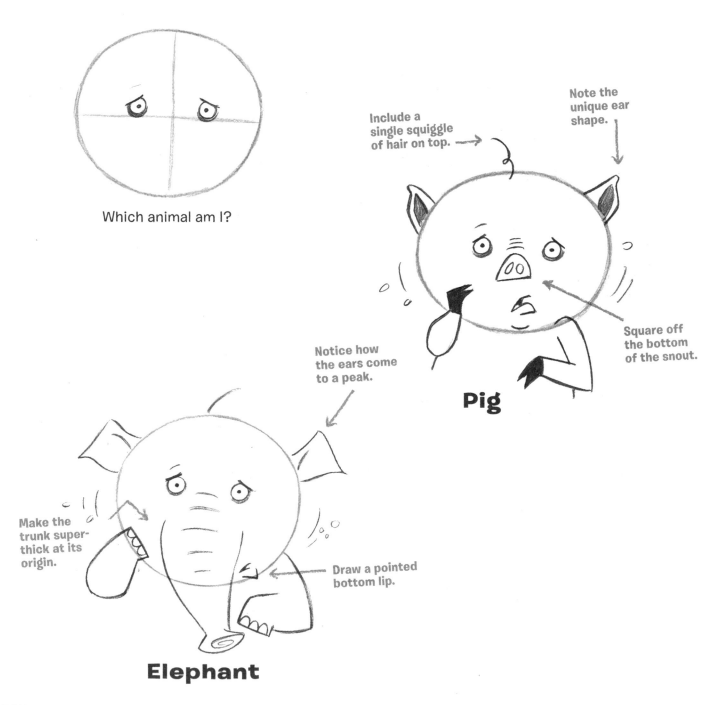

Which animal am I?

Include a single squiggle of hair on top.

Note the unique ear shape.

Square off the bottom of the snout.

Pig

Notice how the ears come to a peak.

Make the trunk super-thick at its origin.

Draw a pointed bottom lip.

Elephant

Draw a pig and an elephant!

A RACCOON OR A KITTY?

What do a raccoon and a kitty have in common? They both have wide faces. Raccoons have black "eye masks," whereas kittens have random markings on their heads. While kitties are finicky, raccoons prefer to tear through the garbage.

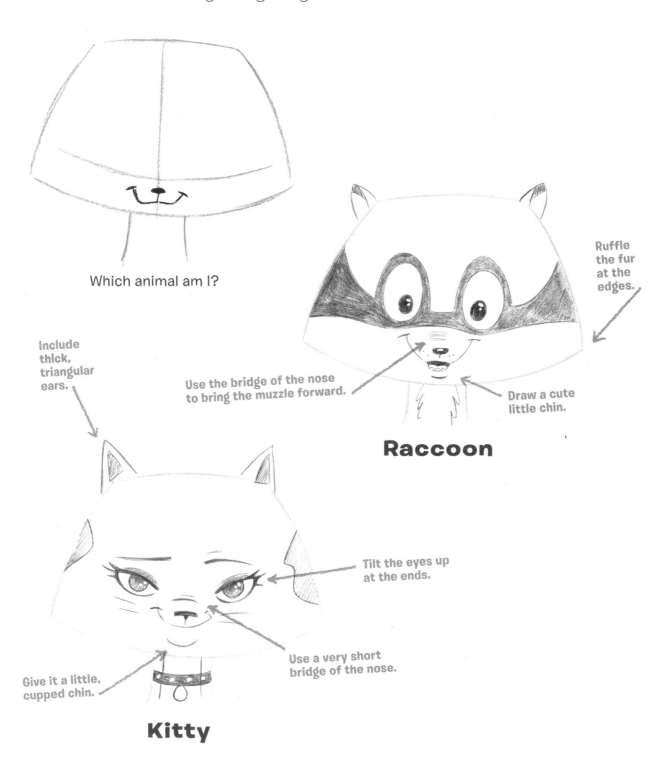

Which animal am I?

Include thick, triangular ears.

Use the bridge of the nose to bring the muzzle forward.

Ruffle the fur at the edges.

Draw a cute little chin.

Raccoon

Tilt the eyes up at the ends.

Use a very short bridge of the nose.

Give it a little, cupped chin.

Kitty

Draw a raccoon and a kitty!

A HORSE OR A COW?

When it comes to drawing horses or cows, it's all about the nostrils. The cow's nostrils are really big. You could fly a zeppelin through those nostrils. The horse's nostrils are big, but not quite as big. Maybe only half a zeppelin. I like to make these characters plump to give them a friendly look. Another technique for making these animals look friendly is to draw squiggly lines for their manes.

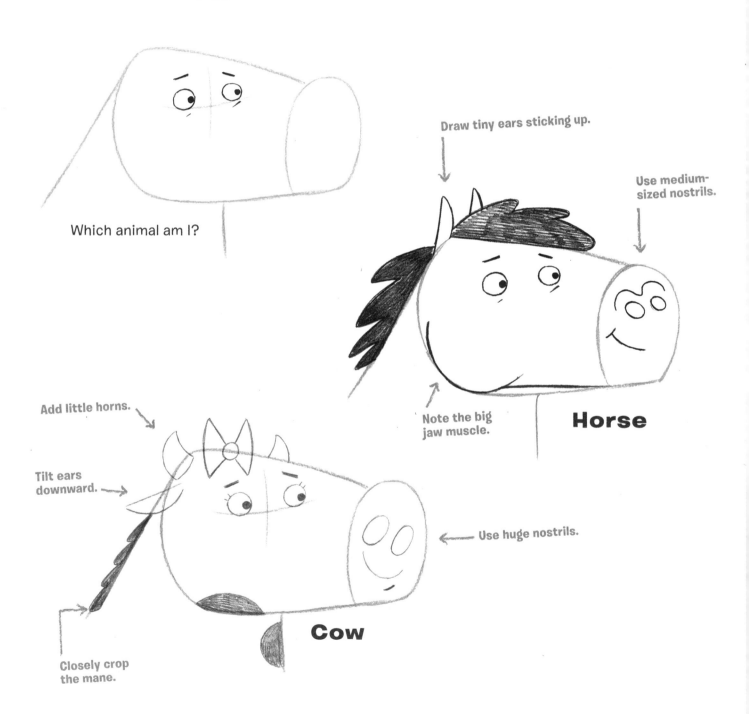

Which animal am I?

Draw tiny ears sticking up.

Use medium-sized nostrils.

Note the big jaw muscle.

Horse

Add little horns.

Tilt ears downward.

Use huge nostrils.

Closely crop the mane.

Cow

Draw a horse and a cow!

AN ALLIGATOR OR A WOLF?

The alligator and the wolf are two really different animal types. One is a reptile, the other is a canine. One has scales, the other has fur. One makes a bad pet and the other makes . . . well, also a bad pet. Nevertheless, in cartoons, they are almost twins! You can exaggerate their goofiness by making their snouts extra long and by giving them a few unwieldy teeth. I love to draw puzzled predators, because they look the opposite of what you would think. It's like drawing an honest politician. Nah, that would be stretching it.

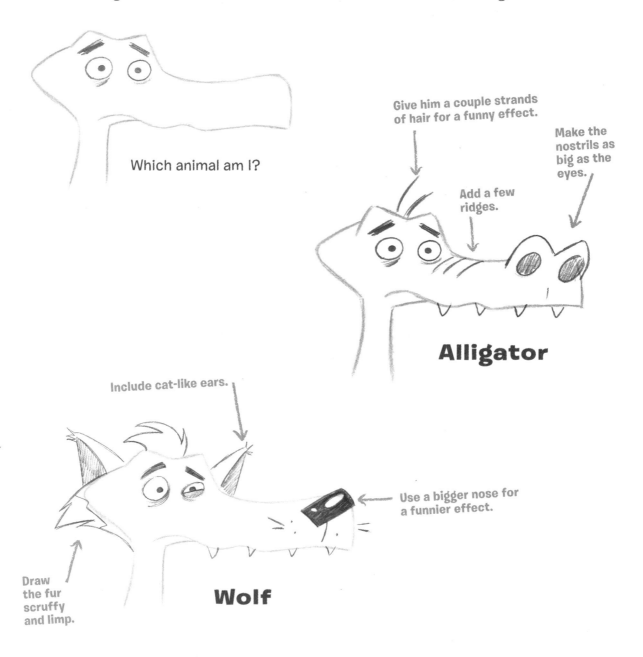

Which animal am I?

Give him a couple strands of hair for a funny effect.

Make the nostrils as big as the eyes.

Add a few ridges.

Alligator

Include cat-like ears.

Use a bigger nose for a funnier effect.

Draw the fur scruffy and limp.

Wolf

Draw an alligator and a wolf!

A LION OR A TIGER?

The lion is like a tiger, but with an Elvis hairdo; however, there are a few more differences between them. For example, *lion* starts with the letter L, and you certainly can't say that about a tiger. Better example? Okay, here's another: the ruffles on the sides of the face are more pronounced on a tiger. But the biggest visual distinction is that tigers have stripes. You can make the stripes look funnier if you draw them horizontally across the tiger, rather than vertically.

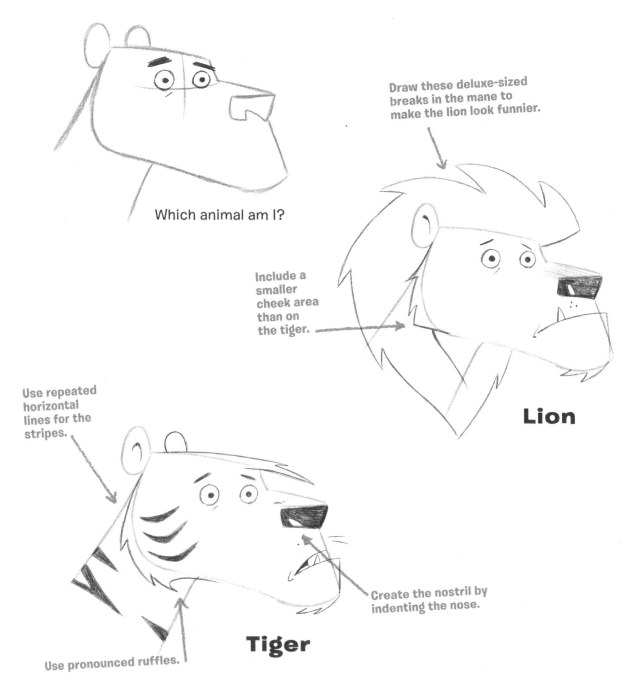

Which animal am I?

Draw these deluxe-sized breaks in the mane to make the lion look funnier.

Include a smaller cheek area than on the tiger.

Lion

Use repeated horizontal lines for the stripes.

Create the nostril by indenting the nose.

Tiger

Use pronounced ruffles.

Draw a lion and a tiger!

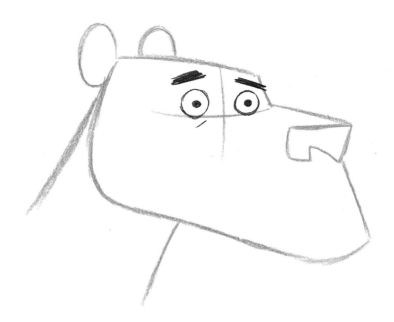

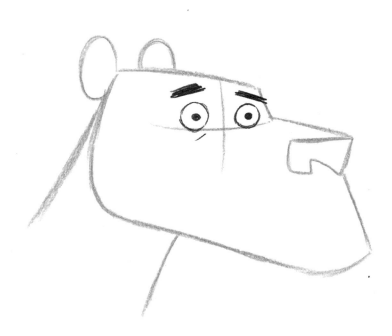

A GORILLA OR A HUMAN?

The gorilla is one of man's closest relatives. The other is the free-loading brother-in-law, followed closely behind by your weird uncle. These two share a lot in common. Both have small skulls, big mouths, and thick necks. Both have awful haircuts. One important, sometimes-overlooked difference is that the ape's mouth is lower on the face than the human's. This gives the ape a huge space between the nose and the upper lip.

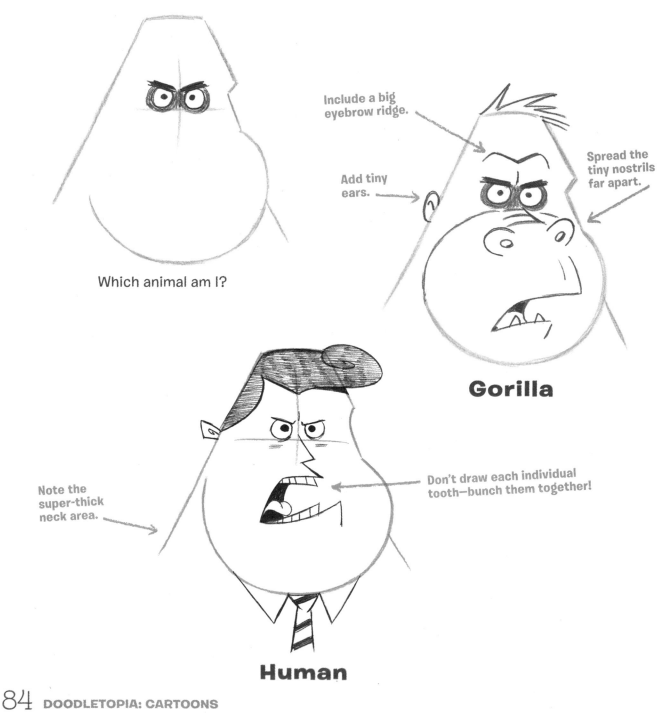

Which animal am I?

Include a big eyebrow ridge.

Add tiny ears.

Spread the tiny nostrils far apart.

Gorilla

Note the super-thick neck area.

Don't draw each individual tooth—bunch them together!

Human

Draw a gorilla and an angry man!

A DOG OR A FERRET?

It sounds like the beginning of an old joke: A dog and a ferret walk into a psychiatrist's office. . . . Or, if you want to update the joke: A dog and a ferret log onto an online therapy website. . . . Dogs are super-popular pets. Ferrets, not so much. Maybe it's because the words *cuddly* and *weasel* don't seem to go together. But that doesn't matter, because cartoonists can work their magic to make both these animals appear equally cute.

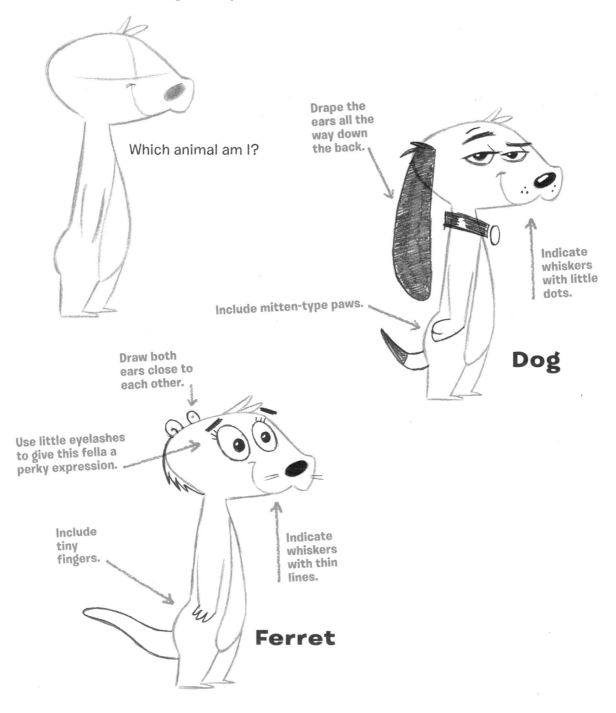

Which animal am I?

Drape the ears all the way down the back.

Include mitten-type paws.

Indicate whiskers with little dots.

Dog

Draw both ears close to each other.

Use little eyelashes to give this fella a perky expression.

Include tiny fingers.

Indicate whiskers with thin lines.

Ferret

Draw a dog and a ferret!

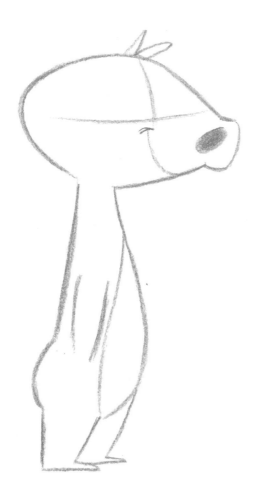

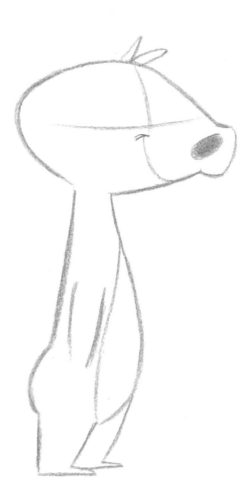

A BEAVER OR A RABBIT?

These two critters are among my favorite cartoon character types. I'm sorry if that hurts the feelings of any of the other cartoon animals I draw. I'm really going to hear about this the next time I draw a yappy chipmunk. Both of these woodland cuties have buckteeth. Their features can be highly exaggerated, especially their bushy cheeks. But the ears and tail are very different, and those differences are what give each their signature looks.

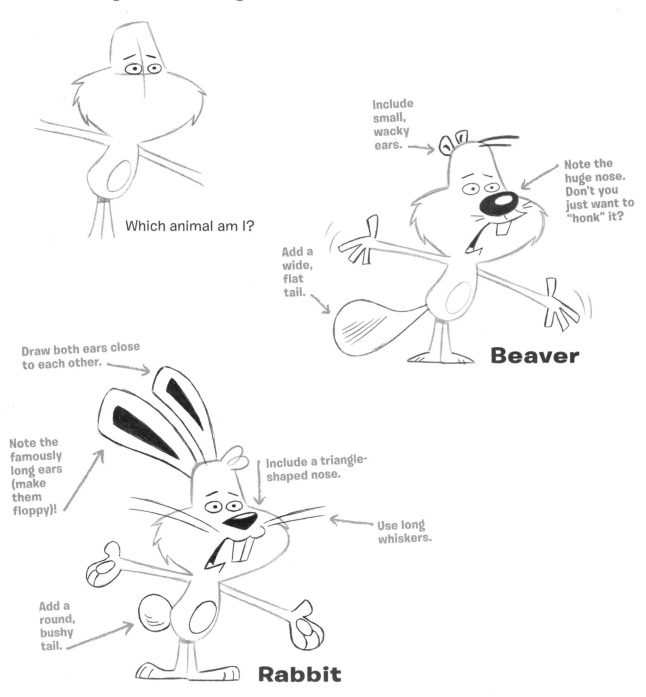

Which animal am I?

Include small, wacky ears.

Note the huge nose. Don't you just want to "honk" it?

Add a wide, flat tail.

Beaver

Draw both ears close to each other.

Note the famously long ears (make them floppy)!

Include a triangle-shaped nose.

Use long whiskers.

Add a round, bushy tail.

Rabbit

Draw a beaver and a rabbit!

A TURTLE OR AN ARMADILLO?

Turtles and armadillos are both low to the ground. But that's where the similarities end. Armadillos are quite odd looking. And their diets consist mainly of bugs—gross!

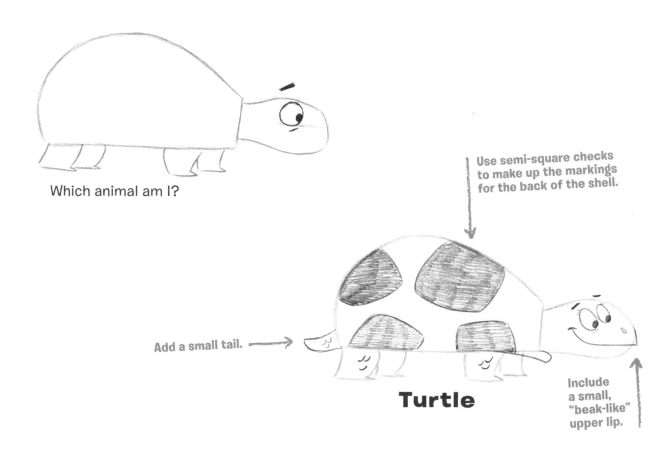

Which animal am I?

Use semi-square checks to make up the markings for the back of the shell.

Add a small tail.

Turtle

Include a small, "beak-like" upper lip.

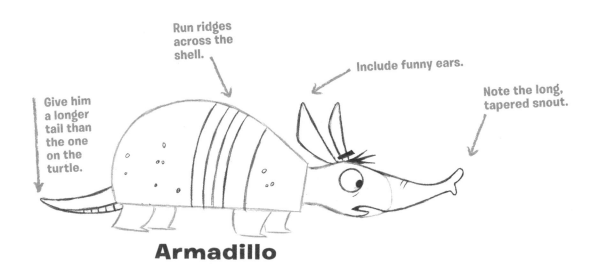

Run ridges across the shell.

Include funny ears.

Note the long, tapered snout.

Give him a longer tail than the one on the turtle.

Armadillo

Draw a turtle and an armadillo!

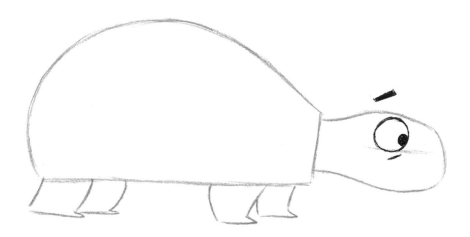

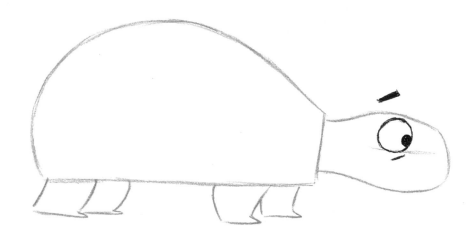

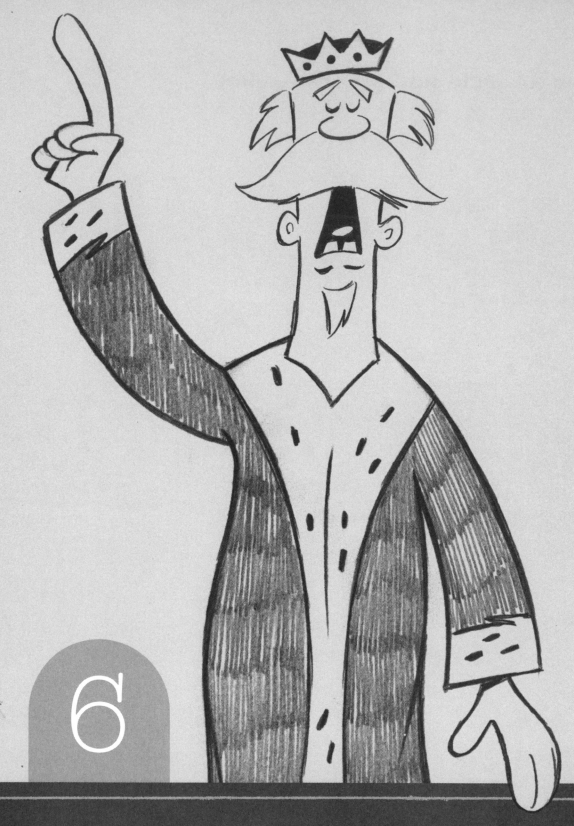

Dress Up
Your Cartoons

Costumes make great characters. Put a regular guy in a ten-gallon hat, and suddenly, you've got a cowboy. In this chapter, you're going to draw the funniest cartoon costumes ever made and place them on many popular cartoon character types. I'll provide a selection of outfits on one page. On the opposite, I'll post the character. It's up to you to choose one of the costumes—or even a combination of them—to outfit the character.

PIRATE

Shiver me timbers! (Why do pirates' timbers always "shiver"? And what's a "timber" anyway? We may never know the answer to these questions, but should we let that stop us? Of course not!) Pirates are among the funniest cartoon characters on the planet. They're also angry, cutthroat, sloppy, and thieving. What's not to like? Here, you've got this season's selection of two pirate costumes. The striped shirt is simply a stunning choice for pirates who swab the deck. The long jacket is a limited edition designed exclusively for captains.

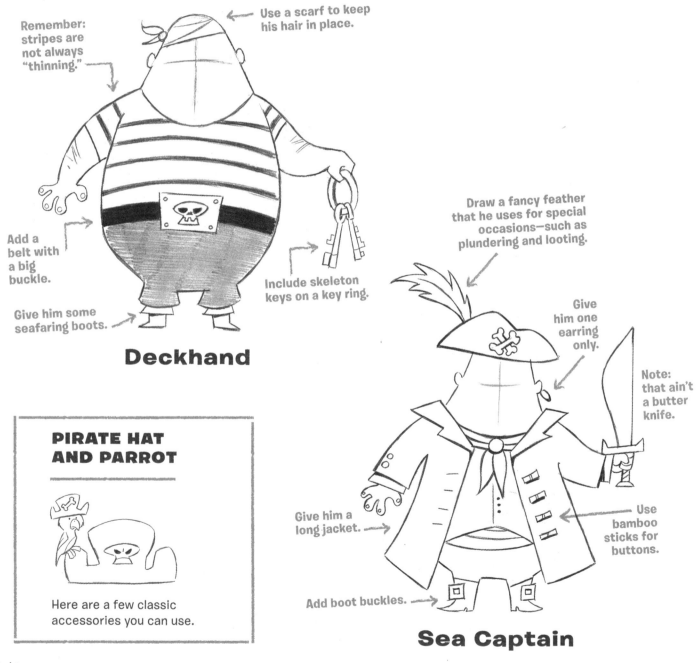

Use a scarf to keep his hair in place.

Remember: stripes are not always "thinning."

Add a belt with a big buckle.

Include skeleton keys on a key ring.

Give him some seafaring boots.

Deckhand

Draw a fancy feather that he uses for special occasions—such as plundering and looting.

Give him one earring only.

Note: that ain't a butter knife.

Give him a long jacket.

Use bamboo sticks for buttons.

Add boot buckles.

Sea Captain

PIRATE HAT AND PARROT

Here are a few classic accessories you can use.

Now draw your own costume for this scurvy scoundrel.

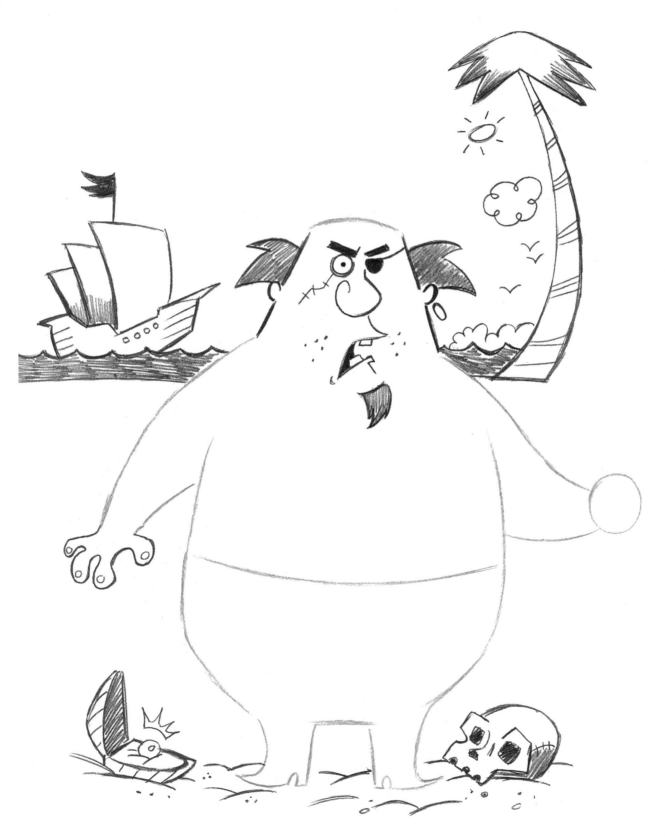

KING

It was hard to be the king's tailor in days of old. If you made the cuffs too short, it was "Off with your head!" If you made them too long, your head would also come off. That is why, historically, there was a shortage of tailors in the Middle Ages. Here, you've got two outfits to choose from. The first is the quintessential robe—simply a must-have in any king's wardrobe.

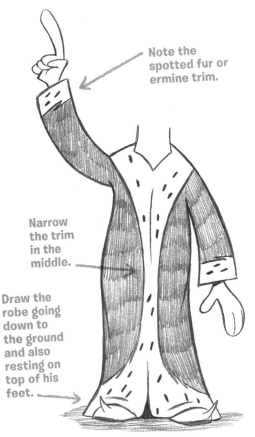

Note the spotted fur or ermine trim.

Narrow the trim in the middle.

Draw the robe going down to the ground and also resting on top of his feet.

The King's Robe

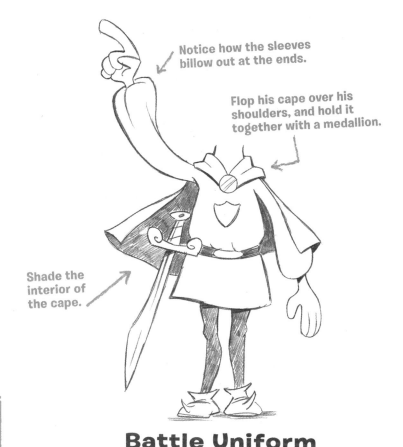

Notice how the sleeves billow out at the ends.

Flop his cape over his shoulders, and hold it together with a medallion.

Shade the interior of the cape.

Battle Uniform

THE ROYAL HAT SHELF

Crowns were great for communicating status and covering up balding heads.

Now draw your own royal clothes!

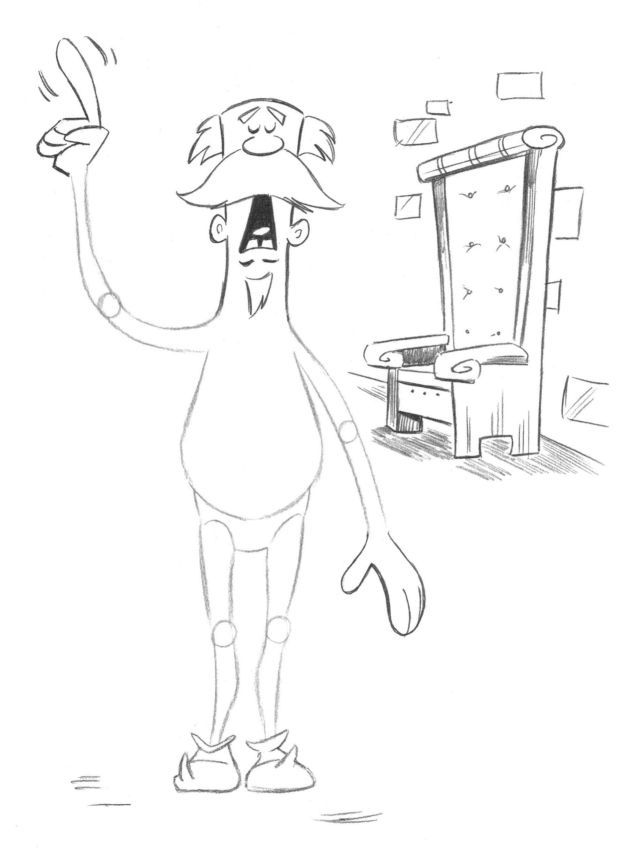

CLEOPATRA

Do you like the arm position featured here? Imagine having to walk like that all day long. Man, your shoulders would really start to burn. Cleopatra was Queen of the Nile—and a regular fashion plate. Her outfits consisted of long dresses and sometimes included things like flowing capes or scarves. Make sure to give her lots of jewelry. She was really into that.

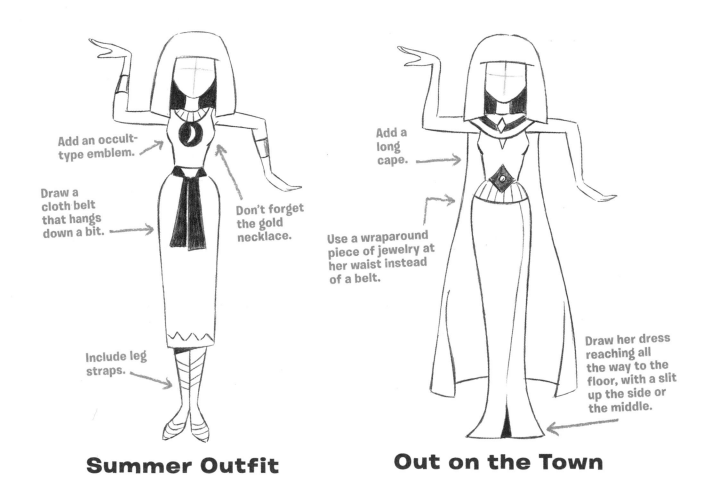

Add an occult-type emblem.

Draw a cloth belt that hangs down a bit.

Don't forget the gold necklace.

Include leg straps.

Summer Outfit

Add a long cape.

Use a wraparound piece of jewelry at her waist instead of a belt.

Draw her dress reaching all the way to the floor, with a slit up the side or the middle.

Out on the Town

THE SNAKE HEAD

Create a thin, "snapping" forked tongue.

Draw a snazzy outfit for Cleo!

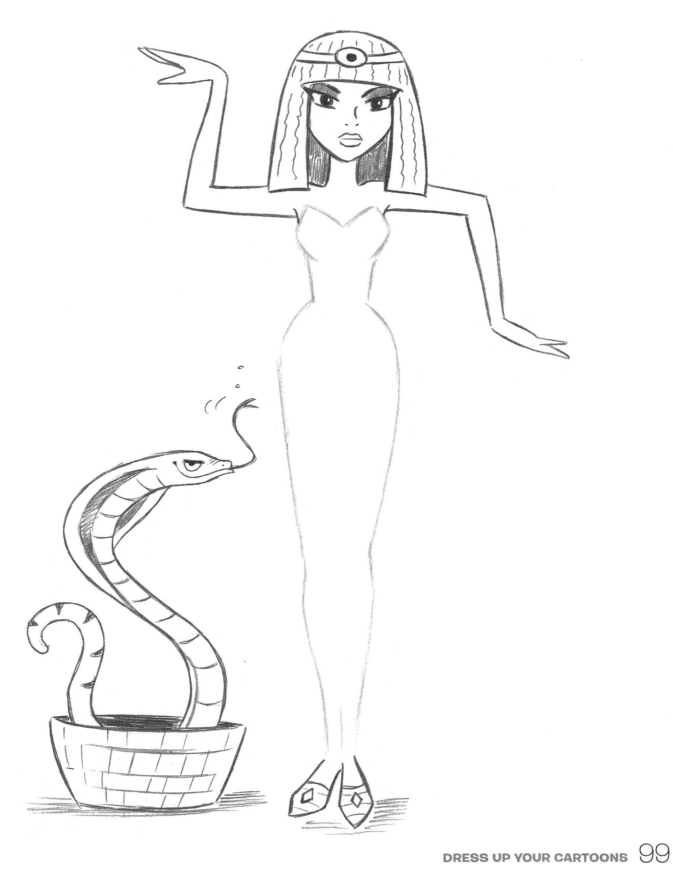

DANCING SHERIFF

In the Wild West, it often took a brave man to keep the townsfolk safe from the gunslingers. Unfortunately, this guy isn't that man. But since everyone else ran for cover, he will have to do. Start with a ten-gallon hat and boots. Since he's a lawman, this sheriff requires a bit more than those features to make him look official. That's why he's also got a fancy leather jacket, chaps, and a tin star. As you can see, he's also a great dancer. He has to be. Bad guys are always shooting at his feet.

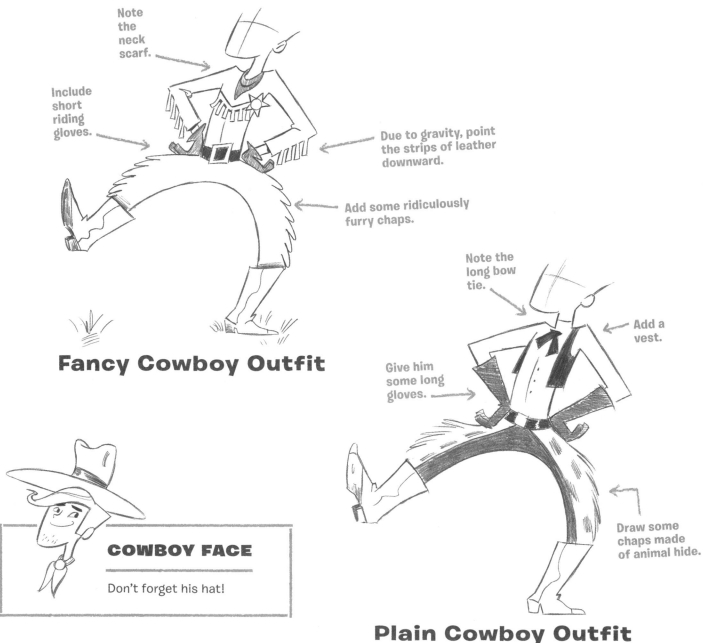

Fancy Cowboy Outfit

Plain Cowboy Outfit

COWBOY FACE

Don't forget his hat!

Draw some cool duds on this rootin', tootin' cowboy!

CAVE GIRL

Way, way back, a long time ago, before there was texting, before there were cell phones, even before there was a gourmet coffee shop on every corner (yes, there was such a time), primitive humans roamed the earth. They hunted and they gathered. It was a good time to be a hunter-gatherer. But it was a bad time to be hunted and gathered, as this character clearly demonstrates. Animal skins were in vogue. If you were a lucky hominid, you could make some cool accessories for yourself. Or you could simply steal them from the weaker members of your clan. The point is, you had options.

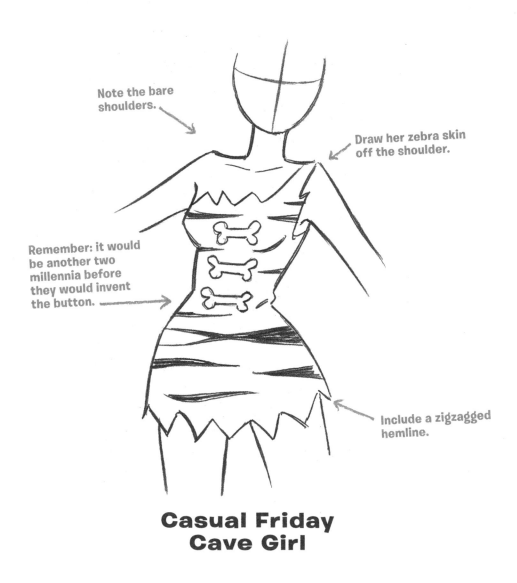

Note the bare shoulders.

Draw her zebra skin off the shoulder.

Remember: it would be another two millennia before they would invent the button.

Include a zigzagged hemline.

Casual Friday Cave Girl

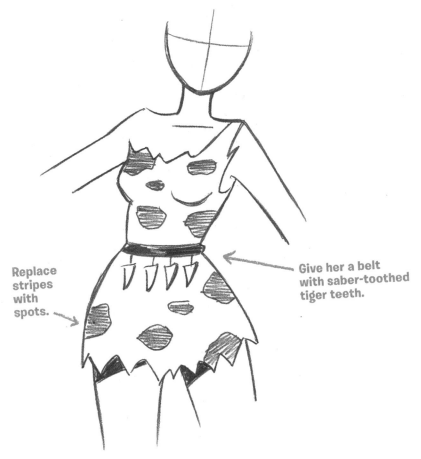

Replace stripes with spots.

Give her a belt with saber-toothed tiger teeth.

Evening Cave-Wear

NECKLACE

Include a necklace to remind her of her one true love. Actually, that necklace *is* her true love.

OTHER ACCESSORIES

Her accessories, though primitive, have style.

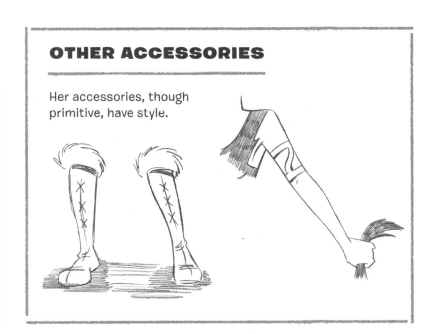

HIPSTER

You know guys like this. He's the one who's always ahead of you in line for gourmet coffee. He's the one taking fifteen minutes to give the barista very detailed instructions on how to make his latte. Resist the urge to scream at him. And don't key his car either. (Well, maybe you can key his car.) Anyway, dressing this character is all about mixing and matching outfits. He spends hours making sure that his wardrobe looks spontaneous. I like to draw hipsters with thin bodies for very practical reasons: it allows me to use layers of clothing without making the character appear bulky.

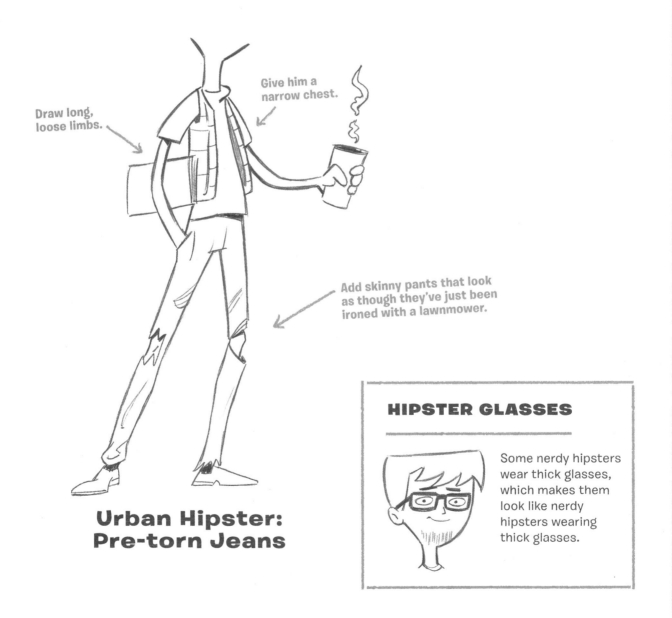

Draw long, loose limbs.

Give him a narrow chest.

Add skinny pants that look as though they've just been ironed with a lawnmower.

Urban Hipster: Pre-torn Jeans

HIPSTER GLASSES

Some nerdy hipsters wear thick glasses, which makes them look like nerdy hipsters wearing thick glasses.

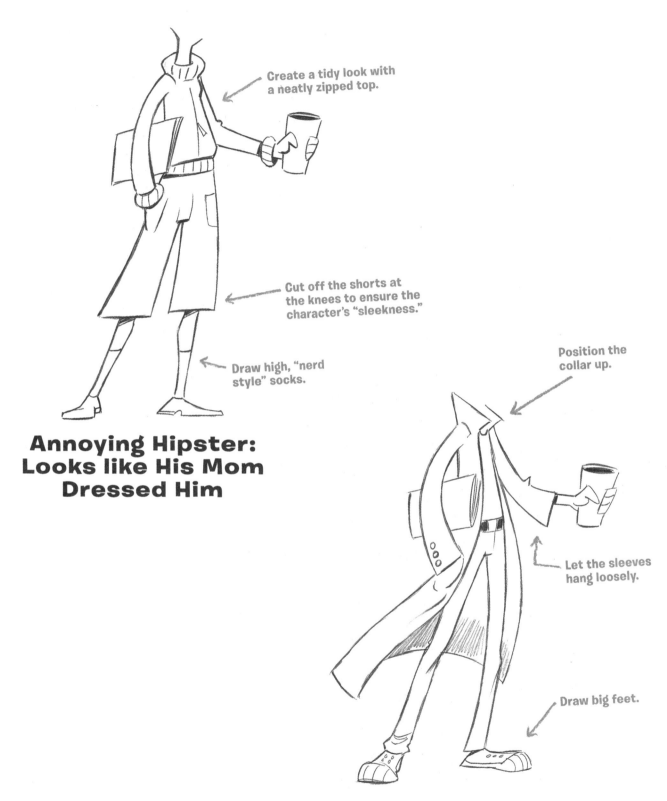

Create a tidy look with a neatly zipped top.

Cut off the shorts at the knees to ensure the character's "sleekness."

Draw high, "nerd style" socks.

Annoying Hipster: Looks like His Mom Dressed Him

Position the collar up.

Let the sleeves hang loosely.

Draw big feet.

Artistic Hipster: Trench Coat Flapping

Draw your own coolest-of-the-uncool clothes for this hipster.

SUPER-AMAZING HERO

Every superhero needs a cool costume. You can't go around kicking gigantic reptilian butt unless you look the part. Skintight costumes are easiest to draw. All you have to do is draw patterns and designs on the character's body, add a belt and some gear, and voilà—super costume. Here are some tips for drawing superhero costumes: Don't make your designs cheerful and bubbly. (So, no repeated designs of whales, or smiley faces. People root against people wearing smiley faces, not for them.) The costumes must look menacing, even for good characters. A futuristic outfit is also a good choice. (But it should come from pretty far into the future. Next season isn't far enough.)

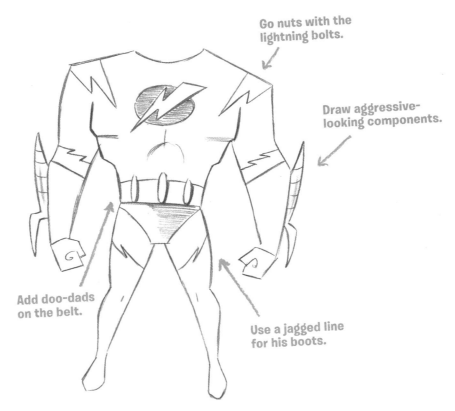

Go nuts with the lightning bolts.

Draw aggressive-looking components.

Add doo-dads on the belt.

Use a jagged line for his boots.

All-Purpose Superhero:
Need Some Brawn?
Call This Guy.

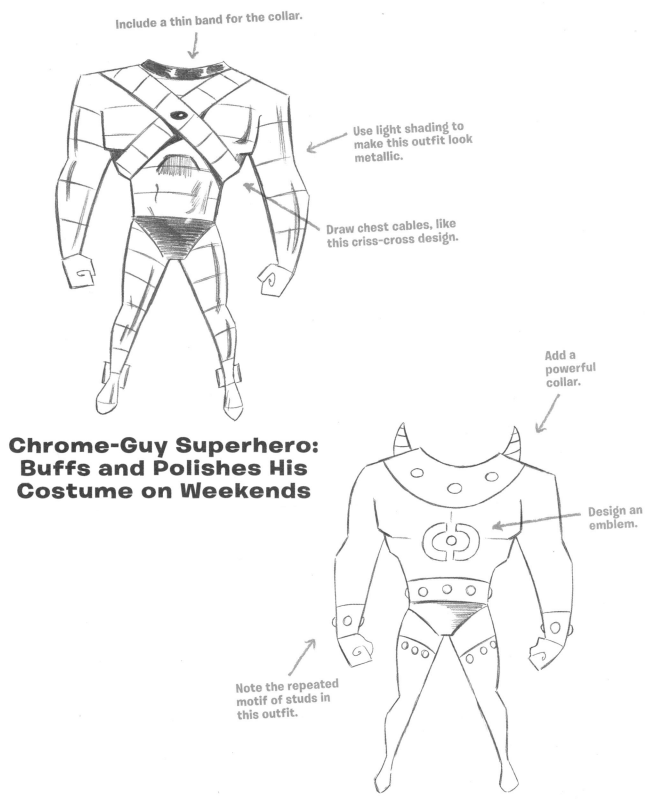

Include a thin band for the collar.

Use light shading to make this outfit look metallic.

Draw chest cables, like this criss-cross design.

Chrome-Guy Superhero: Buffs and Polishes His Costume on Weekends

Add a powerful collar.

Design an emblem.

Note the repeated motif of studs in this outfit.

Future Gladiator Hero

Draw your own superhero costume on this heroic slab.

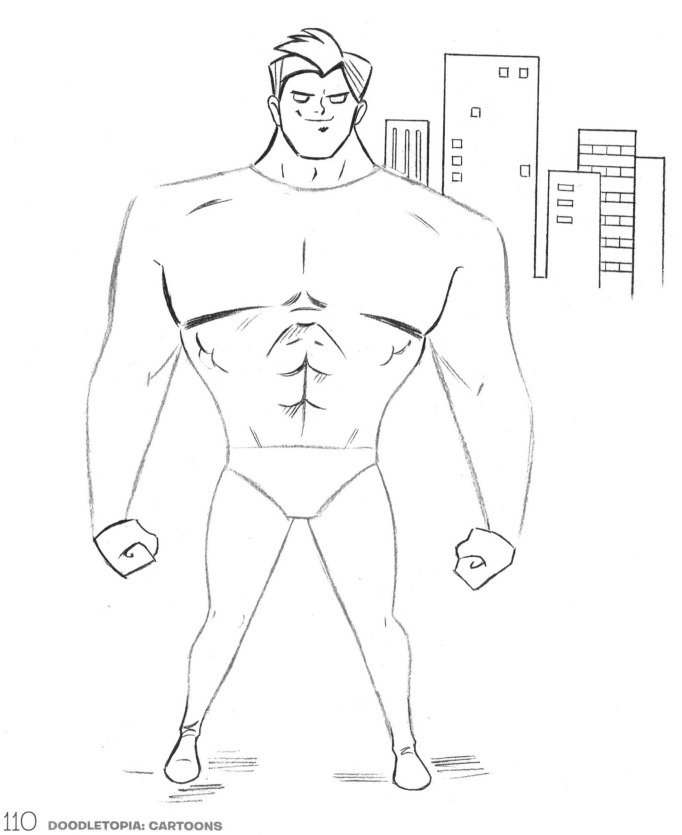

SUPERHERO WITH STYLE

Don't be afraid to push the envelope when drawing a superhero costume. No one is going to say, "Hey, that costume doesn't look practical." The purpose of a superhero costume is to look flashy and eye-catching.

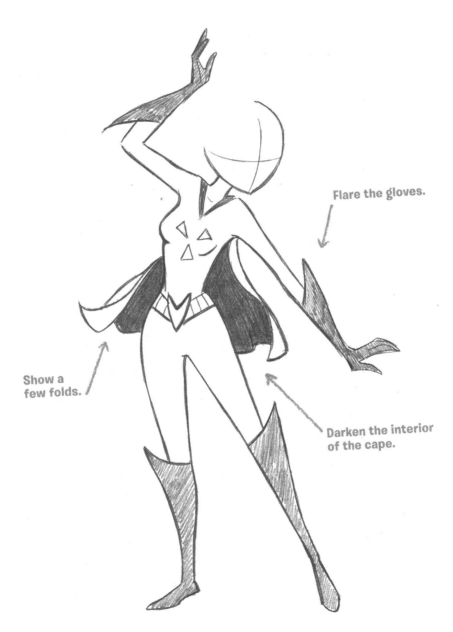

Flare the gloves.

Show a few folds.

Darken the interior of the cape.

Half Cape:
Works Nicely and Saves
on Dry Cleaning Bills

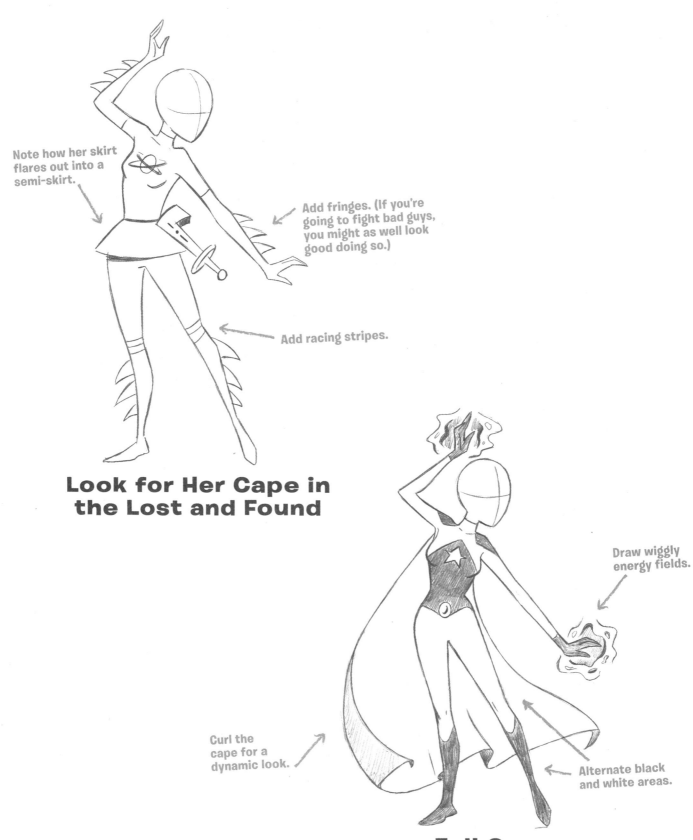

Note how her skirt flares out into a semi-skirt.

Add fringes. (If you're going to fight bad guys, you might as well look good doing so.)

Add racing stripes.

Look for Her Cape in the Lost and Found

Draw wiggly energy fields.

Curl the cape for a dynamic look.

Alternate black and white areas.

Full Cape: Dramatic Length

Draw a stylish costume for this superhero!

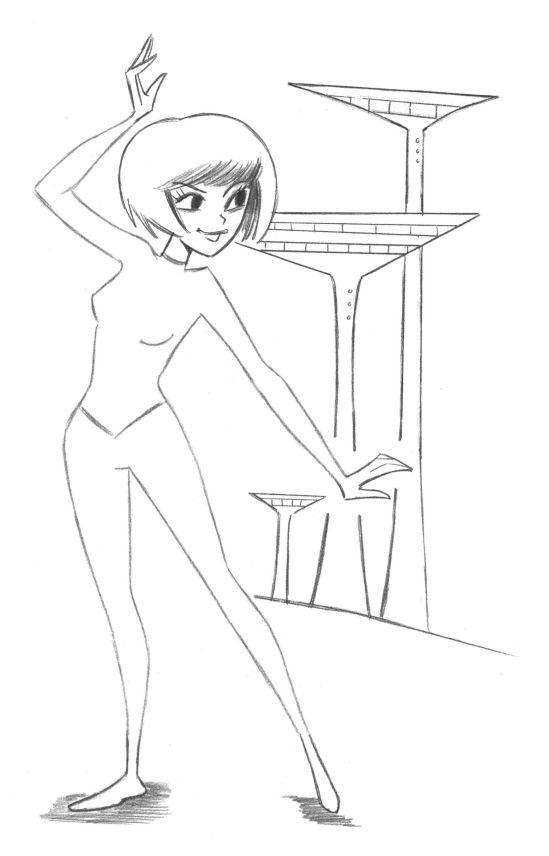

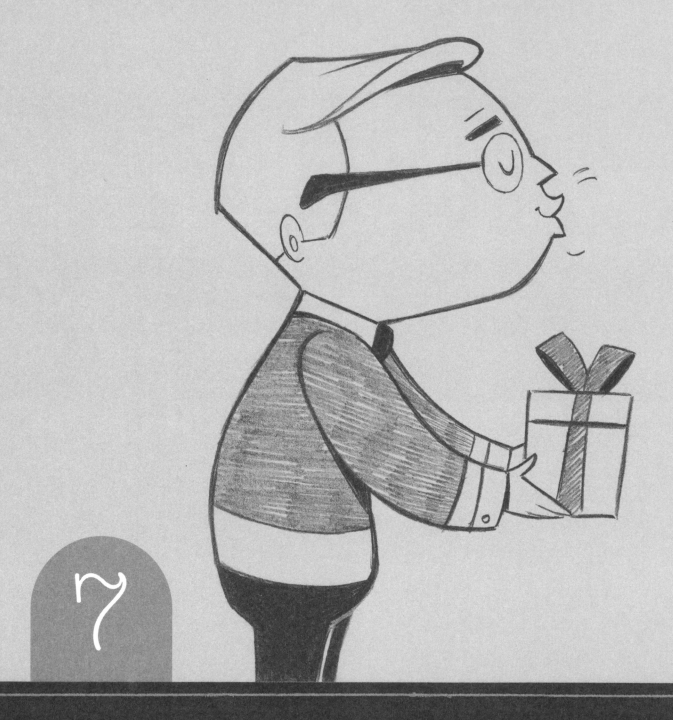

7

Finish the Funny Couples

Have you ever wanted to be a matchmaker? I used to try to set up my friends all the time. Now they're all divorced, and no one will talk to me. Whether they get along or not, cartoon couples are funny. Drawing couples requires two different approaches at the same time: they need to have something in common visually, yet each character also needs to look unique. In this chapter, you'll pair up some unlikely characters.

An important element for drawing couples is to make sure that they make eye contact with each other. Make sure that each character is looking directly at the other character. That shows a connection, even if it's a humorous one.

MOM AND DAD

In this section, I've drawn a picture of a cartoon mom and dad. But—this is so lame—I forgot to draw the mom character. It's up to you to complete the picture by drawing her. I've set it up so that the characters are sharing an affectionate smile. Therefore, give the mom happy eyes (big and round, with long eyelashes and high eyebrows) and a small smile. Notice that both characters are facing each other in a ¾ view (between a front view and a profile). One trick you can use to make her appear to be looking upward is to draw an upturned nose.

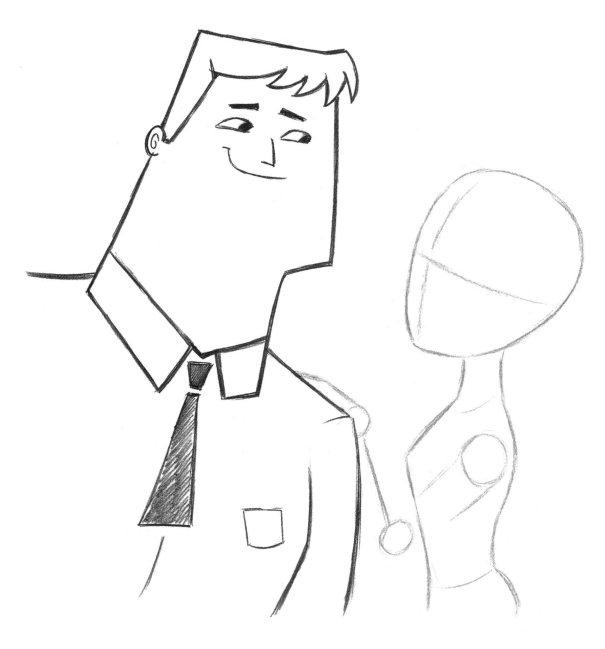

ENDLESS LOVE

Remember when you saw your parents kiss? It was so sentimental. So touching. *So disgusting!* Cartoons can turn anything into a charming moment. Make sure you curl the lips of the woman into a semi-smile. It doesn't matter whether you draw the woman's eyes open or closed, but be sure to add some eyelashes. Her hairstyle should be contemporary but not terribly stylish. Fashion a conservative dress or blouse for her.

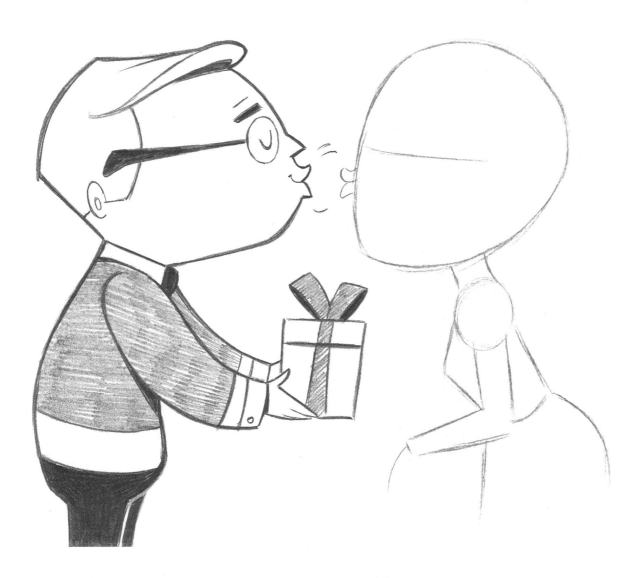

MOM AND POP VIKINGS

Aw, look . . . these two are expecting a tiny plunderer! Vikings are favorites as comic strip characters, animation characters, and comic book characters. The only place where they weren't loved was in the past, because they stole everyone's stuff. (Funny how that works.) Draw a horned hat, a full beard, a grizzly expression, a fur vest, and you've got a male Viking. If you want to accessorize his outfit, draw him holding a ham hock with a bite out of it.

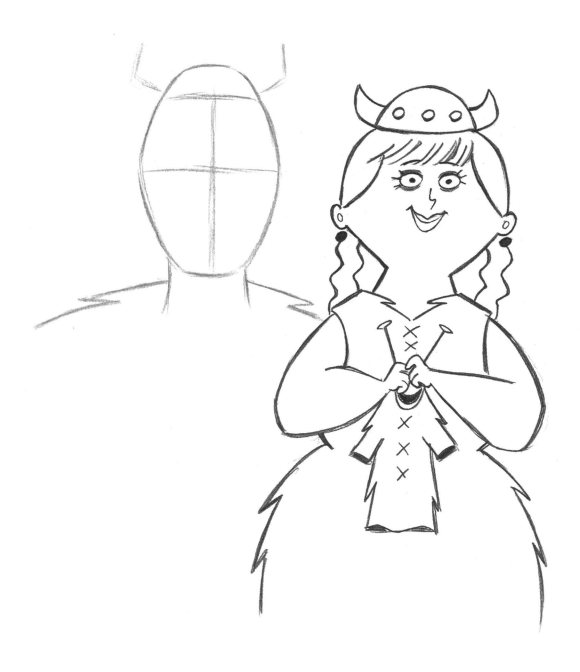

GOOD COP AND BAD GUY

What type of expression should the bad guy have here? Is it an embarrassed grin, a look of fear, an evil thought on his face, or something else? You could draw him staring back at the cop. But that's not the best strategy for staying out of trouble. Maybe this cartoon criminal should feign a look of innocence with a halo added above his head? The less believable the innocent look, the funnier it will appear. Here are a few visual elements that cartoon bad guys have in common: scruffy faces, unkempt or oily hair, and dark circles under the eyes.

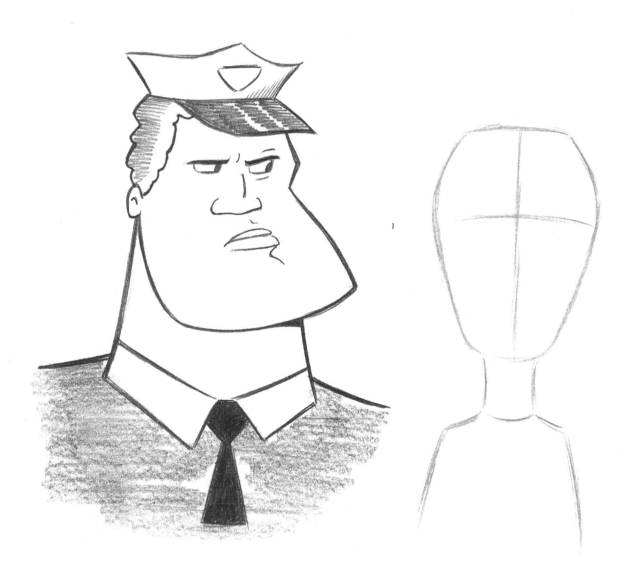

RUNAWAY GROOM

This groom has been thinking about his wedding day for months. Mainly, he's been thinking about how to get out of it. The bride's expression doesn't need to match his. In fact, it's funnier if she's very ecstatic, and he's ... very not. Here are some of the things you can use to flesh out her wedding dress: lace and layers (really overdo it); jewelry; a bouquet (in her hands); a train (drawn as a long swatch of material off to the side); a veil (it can go from the top of her head to the tip of her nose or all the way down to her chin); or a prenup (Oh no! Her forgot to have her sign it!).

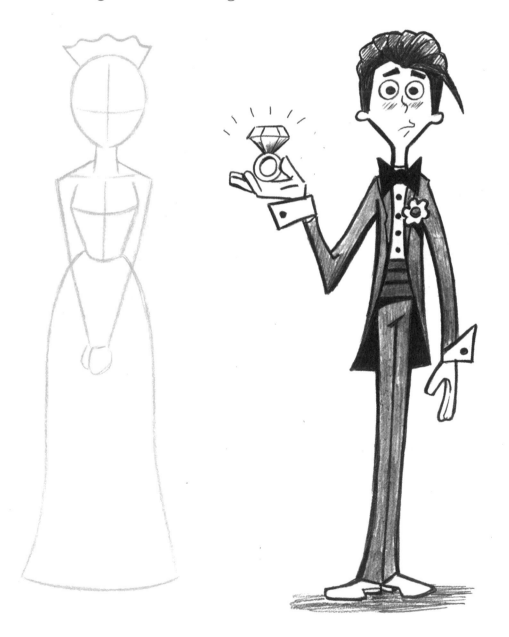

ARGUING SISTERS

You know them, you love them, they're the "I-Told-You-So!" sisters.
Neither sister gives an inch when an important issue is at stake,
even if they forget what the issue is. Since both characters have
similar poses, it's important to find a way to create contrast. There
are several techniques you can use, including drawing different
expressions, different outfits, and different hairstyles. Don't allow the
hairstyles to touch each other. That would result in a *tangent*, which
is an animation term. Tangents break the illusion that there are two
different figures by appearing to attach them.

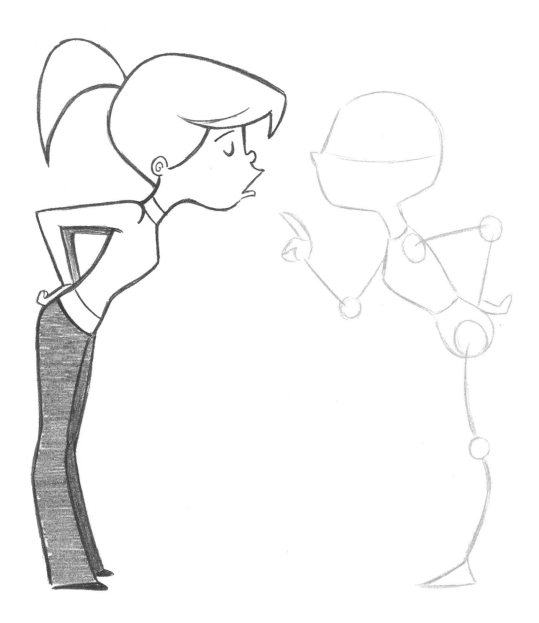

MOM AND PUP

Is there any animal cuter than a puppy? How about a dewy-eyed Portuguese man-of-war? It's hard to come up with one, isn't it? What about a naked mole rat in a pink tutu? I've made my point. Anyway, to make a puppy look even cuter, draw it interacting with its mom. Give the mom a proud look, which you can create with a smile and slightly worried eyes. This combination results in a caring expression. And here's a good idea for a finishing touch: draw the mom's ears so that they droop a bit forward. Drooping ears give a calming look for this mom dog. Upturned ears add a perky look to the pup.

DUGOUT INTERVIEW

When you're a ballplayer and someone sticks a microphone in your face, your job is to make sure you say nothing of any interest, like, "We just went out there today to play ball. We played ball, and they played ball. We all played ball." To make this cartoon funny, have the ballplayer sort of looking off to the side, as if he's trying to read from a cue card. You can also add a speech balloon and write your own funny caption.

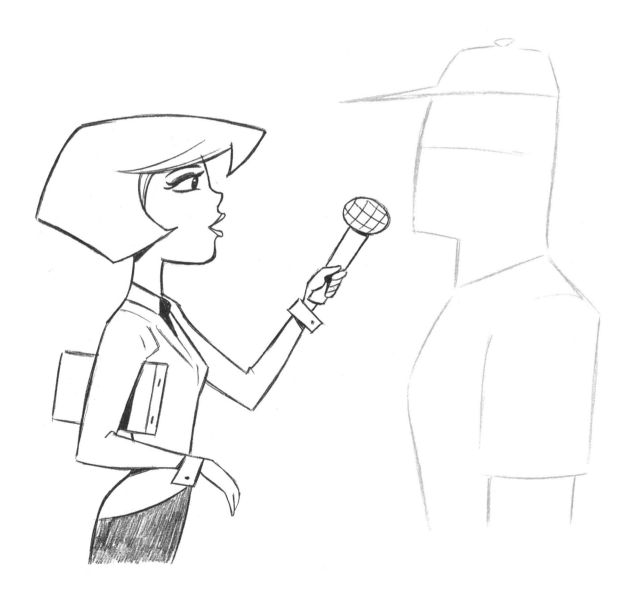

8

Write in Cartoon Calligraphy

No matter how hard I tried to write in script in grade school, my penmanship always looked as if it was written by a cartoonist. Imagine that! The students whose writing was completely *illegible* went on to become doctors. The kids who wrote with *cute* penmanship became Goths. And the kids with *perfect* penmanship are now on work release and doing quite well.

Have you ever tried to write in "cartoon"? Writing in a cartoon style makes any word look funny. In this chapter, I'll show you a selection of hand-drawn fonts. You can copy them as they appear on each page, or improvise and create something of your own.

One of the simplest ways to get started is to write your own name in a cartoon style, or try exclamations like "Ouch!" and "OMG!"

LETTERS WITH CUTE ICONS

By adorning your lettering with flowers, teddy bears, candy canes, or other joyful icons, you can bring a cheery mood to any occasion. This style works well for greeting cards. You can use it to send messages such as "I Miss You." But for more serious messages, like "You Ruined My Life!" there are some better choices, which I will cover shortly.

DEEP LETTERS

Letters drawn in 3-D look solid, like they weigh a lot. The tops and sides of each letter travel into the background, on a diagonal angle. Keep your shading consistent. For example, the dark side should appear on the same side on every letter. Likewise, the bright side. Some people who master the art of 3-D lettering want to press on to 4-D lettering. Unfortunately, there are only three dimensions in this universe. You would have to wormhole through to another dimension to expand upon this lettering style. And I seriously doubt their pencils would be better than ours.

BALLOON LETTERING

Balloon lettering for cartoons is bouncy and round. But, you can get a little more inventive by putting the letters inside of actual drawings of balloons. In fact, you can use many different shapes to frame your letters. Stars work, as do raindrops and tilted squares. You could also draw the letters on a single cartoon zeppelin. The strings dangling off of the balloons turn in different directions, creating variety. Make sure the balloons have only regular air in them. If you use helium, they could fly away.

THE FONT OF DOOM

"Mwa-ha-ha-ha!" I've been waiting all my life to laugh that way in print. Here is the evil lettering style you've been waiting for. I don't mean *evil* in the sense that the individual letters take pleasure in causing trouble. That'd be weird. What I mean is that the letters are drawn to look ominous and spooky. There's goo dripping down them. Anytime something drips goo, it's bad news. If your sister started to ooze goo from the sides of her mouth, it would mean she had turned into a zombie. Dogs with goo, same thing. Fill in the area between the letters with goo, and put a small white shine on the droplets that bead up at the bottom.

CHIPPED BRICK

Texture adds a cool aspect to your letters. *Texture* refers to the look of the surface area, rather than the outline, of the letters. For example, you can draw each letter as a pile of bricks; however, once again, you can be more inventive than that. Show the bricks under a surface of crumbling stucco. It looks like the wall of my first apartment. (You don't want to know what the kitchen looked like.) Notice the little scratch marks on the stucco as well.

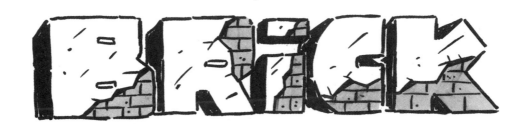

GOTHIC AND HALLOWEEN

Gothic lettering is a sign to *stay away!* If someone is too stupid and doesn't turn back when he or she sees a skull on a sign, well, what can you do? That's natural selection at work. I want you to draw these letters as eerily as you can. That means spikes. And spiderwebs. Insects. Bats. Moons. Eyeballs. And, of course, the ubiquitous rusty, wrought-iron lettering—all in black! You can send a love letter in gothic lettering, but the recipient better be a vampire.

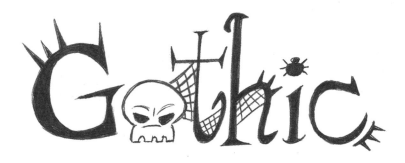

MARQUEE: A STAR IS DRAWN

Be a star! Your name up in lights! I can see it now: you're up there, on the big screen. And now, I see you giving a percentage of all of your income to your agent, manager, lawyer, and the Screen Actors Guild. The rest goes to taxes. Marquee lettering isn't about the letters. It's about the big billboard and Hollywood-style lights that surround them. Note the slight splotch of shading under each lightbulb. These give them the appearance of dimension. Without them, the bulbs just look like little circles.

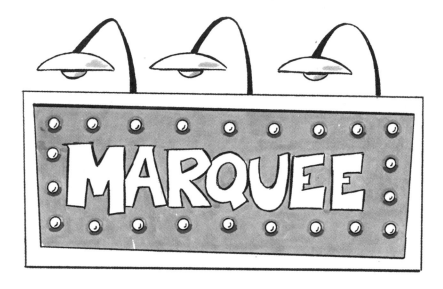

KOOKY LETTERS

Zany lettering comes in any style. Or, to be more specific, it comes in every style. The key is to make sure you don't draw two letters alike. You can vary the size, the tilt, and the patterns of the letters. The jumbled, nonsensical look will make the words curiously legible. Amazed? Don't be, my friend. Save your amazement for things like the beauty of a sunset or for the way they can get all those bubbles to stay in a bottle of soda. But let's get back to my point. Kooky lettering *can* look random. In fact, you can add decorations between the letters. Think of it as visual confetti.

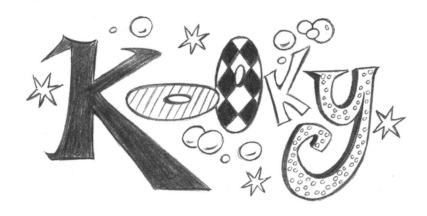

9

Draw Ridiculous Inventions

Crazy inventions are a hysterical subject for cartooning. These contraptions are finely made machines, detailed, elaborate ... and completely useless. Design them to solve a problem that doesn't exist. A product that fills no need.

In this chapter, I'll show you how to take logic to its most illogical extremes. You will doodle away with tubes, gears, wheels, rivets, springs, coils, meters, buttons, and anything else that looks as if it would require a drill. The trick is to overcomplicate things. If one gear would work, well, draw five! Also, the simpler the task, then the larger the machine should be.

COMPLETE THE INVENTIONS

Here's an example of a completed invention. I mean, how ridiculous can you make a seesaw? Therein lies the fun. See the wheels at the bottom of this platform? That's because this is the portable version. After your child has finished playing, you can store it in his closet.

HOW THIS SECTION WORKS

In this section, I've provided the starting elements for insane inventions. But I've left them incomplete. You need to add lots more gizmos to them!

Hydraulic Ping-Pong Power Partner

Here's only part of this invention. It needs a lot more gears and cables to power it. If you really want to get nuts, draw a scoreboard spelling out useless statistics, like how many bounces of the ball in total there have been, or which serves were the slowest.

Toast-Buttering Robot Helper

Who wouldn't want one of these inventions for their birthday? Imagine the convenience of never having to butter your own toast ever again. What would you do with all the extra time on your hands?

Here's how to start this project: Draw a small plate under the toast on a conveyor belt of unbuttered toast. The hydraulic buttering brush needs a power source, naturally. Add gizmos and screens. Make it appear to truly be the most obtrusive device ever to invade a kitchen.

Atomic-Powered Cupcake Maker

It takes a lot of energy to make a cupcake. Now you can make a cupcake with even more energy than before! But wait! I've left some important details out. Where are the computer screens, the fuel and danger meters, the buttons, levers, and other essential thingamabobs? How in the world is someone supposed to bake without all that stuff? It's up to you to doodle the rest of it. If you don't, then you'll be letting down throngs of cupcake gourmets. Let that be on your conscience.

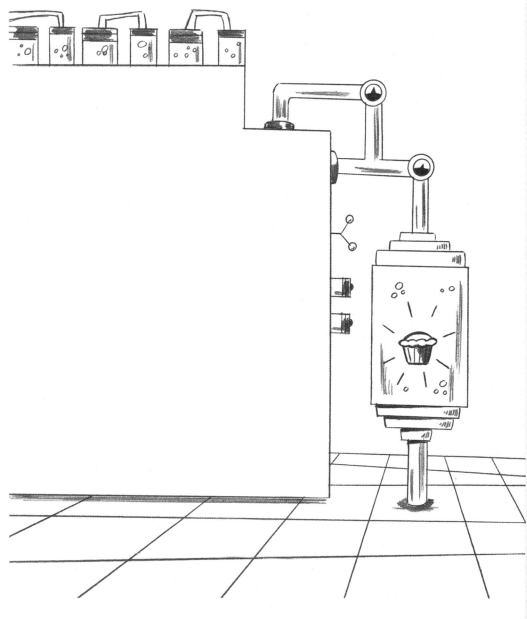

Colossus, the Ultimate Pizza Maker

Don't you hate it when you're waiting for your pizza to be made, the guy tosses it in the air, you watch it veer off course, and, suddenly, you're wearing a pizza hat?

This invention was designed to make sure that this never happens to me, er, I mean, to anyone again. Unfortunately, I only designed part of the machine. I need you to finish the rest.

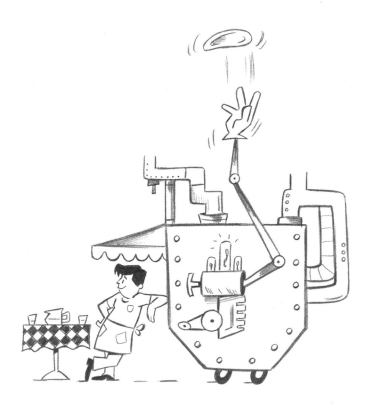

DEVISING SMALLER INVENTIONS

Not all cartoon inventions are behemoths of technology. Many are smaller units and are just as useless as the larger versions. An example is this microwave wristwatch. If you've ever been on the go, and didn't have time to make yourself lunch—your problem is solved. With the new microwave wristwatch, anyone can enjoy a teensy, hot meal from the convenience of his or her own wrist.

YOUR TURN! DOODLE A COMBINATION GUITAR AND SNOWBLOWER

Sometimes, when you're playing guitar in your room, your mom suddenly pops her head into your room and asks you to shovel the snow off the front steps of the house. Until now, you would have to stop playing in order to do your chores. Now, you can do both at the same time! The guitar and snowblowing machine also makes a great graduation present. Draw it below.

Bicycle-Powered Blender

Nowadays, we all have to think about the best ways to "go green." That means saving on electricity and fossil fuels. And there's no better way to do that than to use bicycle power. With this device, creating a chocolate shake burns as many calories as you will consume. Is that genius or what?

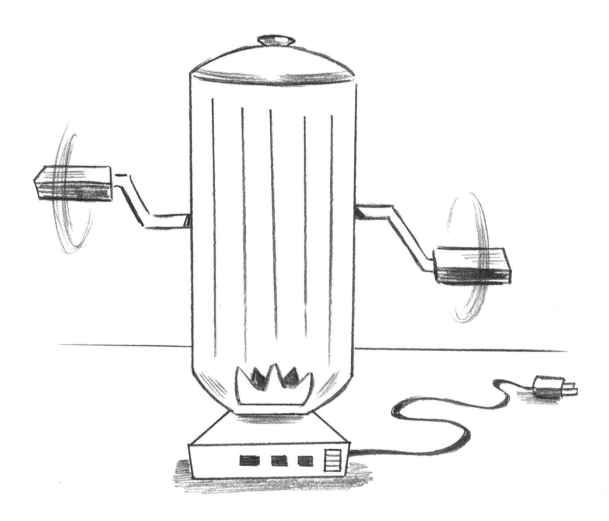

YOUR TURN! DOODLE A COMBINATION HAIRBRUSH AND REMOTE CONTROL

This is such a cool idea. Draw a hairbrush at the end of a handheld remote control unit (like a TV remote control). All the user needs to do is program in the type of hairstyle he or she wants from a menu of 243 options, answer 634 prompts, and voilà!—perfect hair every time. (Caution: never use this electrical device near your face.)

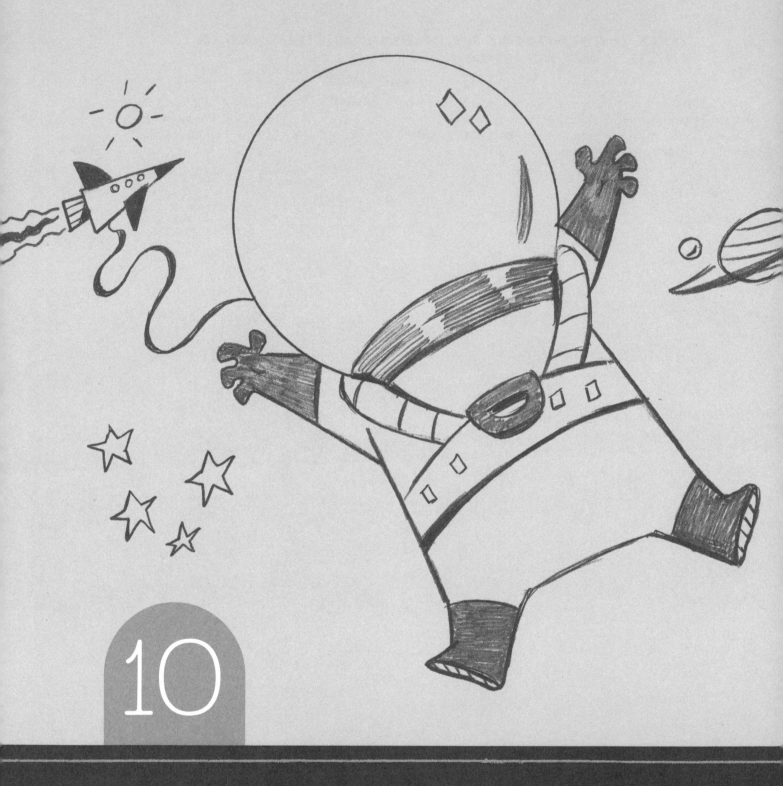

10

Complete the Cartoons

Cartoon humor comes in two parts: the set-up and the pay-off. In this chapter, I have set up the scene. But in my haste, I left off the pay-off. Every drawing is missing the funny part, which you will fill in to complete the picture.

ROBOTIC SOCK FINDER

Look, here's one last invention that I need your help with finishing! If ever there were an invention that begged to be invented, this one is it. Who among us hasn't lost a sock? What if you could design a robot that could seek out and find every sock in your house? I'm starting to hear utterances of "Nobel Prize."

I've drawn the sock-finding drones on the left page. But the right page is curiously empty. Add your own drones until we have an army of sock finders.

THE FAMILY THAT ORBITS TOGETHER STAYS TOGETHER

Here's the family of the future taking a day trip to an asteroid. It's two days of hearing the same refrain: "Are we there yet?" To complete the scene, draw a funny character inside each helmet.

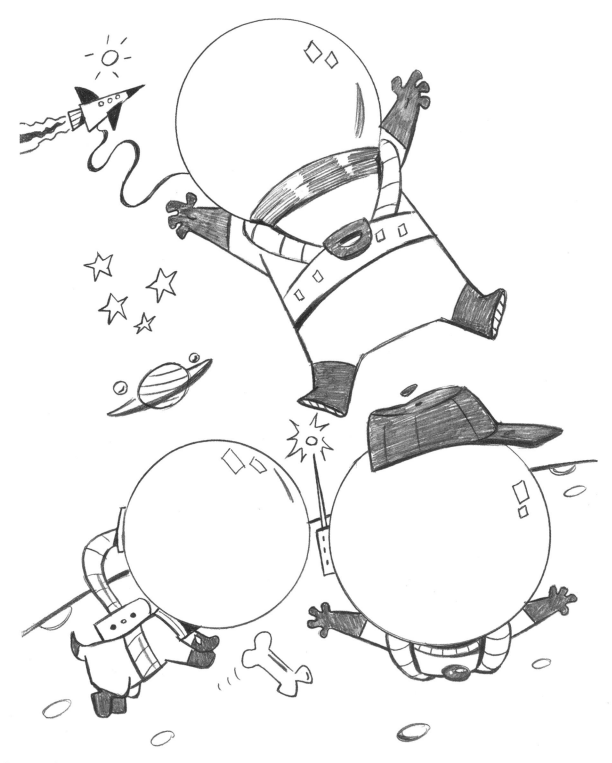

YOU DREAM OF A GENIE

Three wishes, that's all you get. No wishing for more wishes. No wishing for more genies. And no do-overs.

When you draw a genie, make him or her appear impressive and powerful.

IT'S A ZOO AROUND HERE

Look at these cartoon animals. Why the attitude? Maybe it's because I left out a few details when I drew them. Like their identifying features, including spots on the giraffe, stripes on the tiger, and a mane on the lion. They want you, not me, to fill in the parts that have been left out.

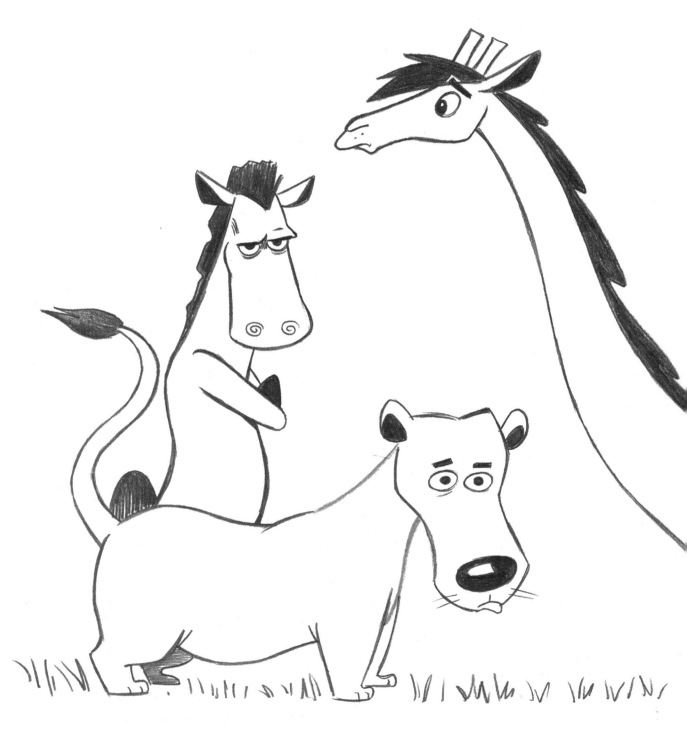

DOES THIS THING HAVE BRAKES?

Have you ever wanted to plunge from an airplane? Me neither. But you can still have fun drawing it. The big parachute in the foreground needs a person attached to it. To make it funny, draw a specific expression on the skydiver, like panic, concern, or glee.

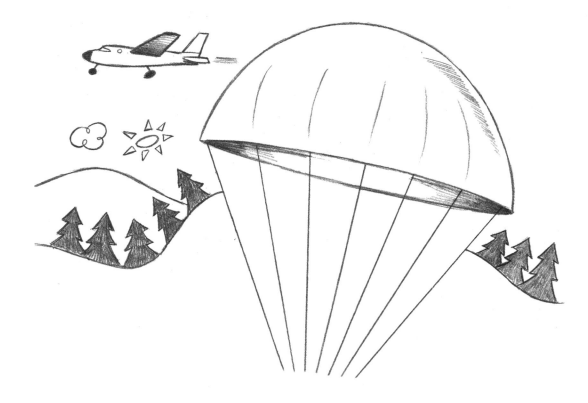

WELCOME HOME!

Here's the extraterrestrial family van. It's supposed to be ferrying a group of noisy little aliens back from sleepaway camp. The s'mores in Andromeda were delicious. Fill in the capsule with squishy little passengers. You can also draw some arriving spaceships in the sky.

GO TEAM!

There should be a cheerleader—called a "flier"—at the top of this pyramid. If a flier gets injured doing her routine, she's called a "plaintiff." In cartoons, a flier can be posed any way you like; however, the arms should be outstretched, away from the body, for balance.

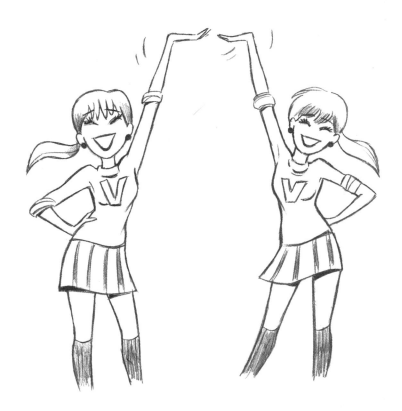

MAN'S BEST FRIEND

Guys and dogs do everything together. They play fetch, they jog, they go waterskiing. In order to heighten the humor even more, you might want to draw a human water-skier having all sorts of difficulty maintaining his balance, while the pup does just fine. Alternatively, you could draw another type of animal on the larger set of skis. Attach the cords to a speedboat on the opposite page.

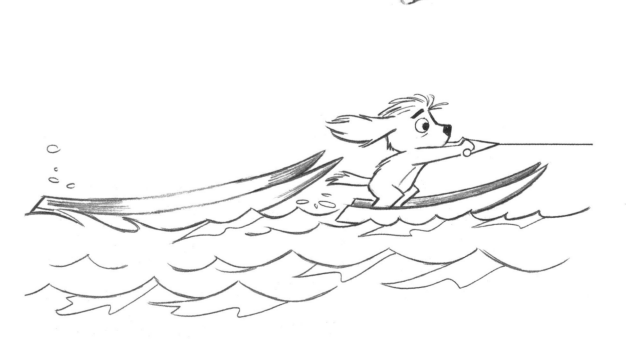

WHOOPS!

There's a reason why it's hard for acrobats to get life insurance. Here's another piece of advice, for those who are aerially inclined: never practice with someone who has a sign on his back that reads STUDENT ACROBAT. Draw the falling acrobat under the speech balloon. Draw a tightrope walker in the background, behind the acrobat on the opposite page.

DRAGON DOODLE

Some people might say that a dragon would never wear a bow in its hair. How do they know? How many dragons have they see *without* bows? They might wear jogging suits for all we know. Below, you can doodle a mom dragon or a friendly princess. Baby dragons are harmless—unless they cough. Then they can set an entire village on fire.